ADT Guide for Interior Designers

Planning

ADT Guide for Interior Designers

1 Planning

Michael Stuart Green

First published in 1990 by

Architecture Design and Technology Press

128 Long Acre, London WC2E 9AN

A division of Longman Group UK Limited

British Library Cataloguing in Publication Data
A CIP catalogue record for this book is available from the British Library

ISBN 1 85454 050 5

Design: Jonathan Moberly
Layout: Diana Taylor
Set in 9/13 point Adobe Linotype Bodoni
Page makeup: Macintosh II + QuarkXpress
Linotronic: Alphabet Set, London

Printed and bound in Hong Kong

Contents

Preface

Design…Especially
of Interiors

The books in this series are concerned with the insides of buildings and, more particularly, with what is entailed in designing them. Each volume is concerned with a different aspect of an extensive and almost boundless subject. None, therefore, can give a complete picture; and, even taken together, a lot remains unsaid, not only because, unlike the subject, books have limits, but also because there is much that cannot be satisfactorily communicated by this medium alone.

What is particularly hard to convey is the complexity of designing itself, in the sense that it is far from being a simple linear sequence involving a few factors only. Instead there are often a vast number of factors to be considered – which interact and conflict in endless and unpredictable ways. This is a source, however, not only of potential confusion but also of potential richness. The designer who can keep all such factors before him simultaneously has a better chance of arriving at a uniquely rich solution to the overall problem, than one who finds it necessary to break

it down into discrete components. But a book that attempted, in itself, to mirror that complexity would be extremely difficult to follow.

So, while out of necessity, this series does indeed break the subject down and focus only on parts of it, readers are asked to remember that this has indeed happened. And just as they should always be mindful of the real complexity of interior design, they should be aware of this author's attitude both to it and to designing generally. In explaining my attitude I shall, of course, have more to say about the nature of the subject itself.

Here, first, are some others' definitions of the term 'design':
1 'An irrational search, conducted over ground prepared by experience, the study of principles and the analysis of site and purpose.' [*Site Planning* by Kevin Lynch, M.I.T. 1962.]
2 'The performing of a very complicated act of faith.' [*Design Methods* by J. Christopher Jones, 1966.]

3 '…the assembly and putting together (composition) of a greater or lesser number of parts.' [*Partie Graphique* by J. N. L. Durand, Paris, 1821.]

4 '…design to a modern mind can only be understood in the scientific, or engineer's sense as a definite analysis of possibilities – not as a vague poetic dealing with poetic matters.' [W. R. Lethaby lecturing the RIBA in 1910 on *The Adventure of Architecture*.]

5 Design '…is planning: the planning as objectively as possible of everything that goes to make up the surroundings and atmosphere in which men live today…' [*Design as Art* by Bruno Munari, London, 1971.]

None, I find, is very helpful. So I ask myself what I think I mean by the term, even to ask myself if such a thing as 'design' actually exists. Is it possible to point a finger and say, unequivocally, 'There, that's design'?

When I started to write this I did not know the answer – at least, not for sure. There was a suspicion in my mind but it needed testing. I was more certain about what I meant by 'designing': the working out or proposing how something might be done; specifically the working out or proposing by means of drawing (from the Italian root verb 'designare') or other communicable, visualizing technique. Because drawing etc. is essential to the process it becomes concerned with the description of what can be seen. Consequently, designers are likely to be as concerned with the precise nature of appearance as with the means of attaining that appearance. Thus graphic designers, while not unconcerned with questions of production, are primarily interested in the visible layout of the page or whatever; product designers take care to understand the production methods used to manufacture their ideas, but also spend much time drawing to determine how those ideas will look; interior designers must interest themselves in a wide range of associated disciplines, from psychology to building technology, but evolve their solutions largely via drawing. The denominator that would seem to be common to all designing is a concern for appearance. Designers tackle all sorts of projects; designers wear all sorts of more or less specific labels denoting areas of specialism; what links them is the preoccupation with appearance. In some areas there is not much else to preoccupy them and appearance can be considered almost in isolation; in others there are so many related, non-visual factors to take account of that appearance would be largely at their mercy, were it not for the designer's determination to prevent it.

So, we know that designers (people who do designing) work in a variety of fields to determine, in advance, how things will be; and that, no matter how taxing (or otherwise) the parameters that limit what might be done, there is a common concern with appearance. Certainly that is how designers are generally perceived; indeed, among those who are not themselves designers, they are often thought to be only concerned with appearance. But that, as I have already suggested is by no means always the case.

But what if one raises the question of blind designers? Are there such people? And if there are, would that not invalidate the notion that all designers are linked by their concern for appearance? But then, is it actually necessary to be able to see something in order to be concerned about its appearance? The answer is, of course, no. Otherwise all blind people would be unutterably scruffy,

which they are not. Someone who is blind can be concerned about how things look to others and, if necessary, can ask them.

But thinking about blind designers serves as a reminder that we possess senses other than sight. After all, none of us can use powers of sight to pre-determine how something might sound or feel; indeed, in these areas, the blind have the advantage of the sighted, being more used to considering such matters. Yes, of course designers care about the appearance of things, but they are also concerned with their effect on our other senses: will tiles make the place sound harsh and noisy? Would foam of that density be too hard to the touch? Would the smell of the rubber flooring be too overpowering in so small a space? Would dental spatulas made of that particular plastic taste unpleasant?

So, it might be more correct to say that designers have a common concern with how things will affect our senses generally – principally sight, but also touch, hearing, smell and even taste; and, to these, interior designers would also add instinct.

Designers are, then, more aesthetically aware than those who are not designers (if only because they consciously exercise and consider those senses more frequently than do others) particularly with regard to sight and appearance. Both in training and in subsequent practice that sensitivity is developed. How is it done?

Simply by doing it. It is essentially personal and cannot be taught. Painters concern themselves with particular visual problems, usually of an evanescent and shifting nature, and every picture is a stab at a personal solution. Likewise designers, even though they usually have other, more practical matters to attend to also, will seek through their designs to reach some personal sense of perfection. For there is no absolute, universal perfection. Numerous philosophers, aesthetes, craftsmen, architects and others have, over the centuries, attempted to define, in various ways, standards by which aesthetic achievement might be gauged or rules to which would-be beauty would need to conform and which, if observed, would ensure success. More often than not they derived their rules from a fascination with numerical relationships and the apparent magic of certain combinations; or the supposed connection between man and particular dimensions. Gestalt psychologists attempted to identify factors common to people's perceptions of what is visually satisfying – revealing common denominators so low as to be of help only at the simplest levels. Others have attempted to show that particular colours affect us in specific ways and that knowledge of their 'behaviour' can be harnessed to good effect by designers – but this tends to overlook cultural differences whereby the 'meaning' that certain colours have for one race or group is by no means the same as for others.

Cultural differences are, in fact, important when attempting to assess aesthetic merit or effect and need always to be taken into account. It is difficult to appreciate the art and design of cultures other than one's own in the same way as it was appreciated by those who originally produced it. This is certainly true of cultures that are of another place, or another time, or both. It is also true of the work or preferences of groups within one's own general

culture, but to which one happens not to belong; and of individuals whose cultural experiences are at variance with one's own. Sometimes it is possible, by means of conscious study, to extend one's own terms of reference to include those of an otherwise alien group and so become able to understand its cultural offerings in much the same way as the originators: this is most easily achieved in respect of work that is contemporary or nearly so. But the further away the source, either in time or space, the less accessible the raison d'être. Of course, unfamiliar objects will always engender some kind of response: it is not necessary to know why they are as they are in order to hate them, enjoy them or to remain indifferent. But in doing that you are employing the references of your own culture and these may be at total variance with the references of those that produced the objects concerned.

The truest thing I ever heard about design came, quite unconsciously I think, from the manageress of a College canteen. I was new (i.e. I had been there only five years) and she had asked me which was my department. I told her. 'Oh', she responded, 'you designers live in a different world'. When Victor Papanek wrote *Design for the Real World*, (London, 1972) his title was saying much the same thing: that designers, or the great majority of them, constitute a cultural group that is quite distinct from the community they might be thought to serve. (Whether designers are a sub-culture within any given national culture, or whether they are now a supra-national culture of their own, or whether there are both kinds can be debated. There is also an ethical dimension to this: should designers, etc. etc.....?)

But who do designers actually serve? Typically, a designer is asked to propose a solution to a given problem: e.g. a design for a new house, a new range of children's clothes or a lunar-powered torch. Such problems pose specific objectives and have specific parameters which together constitute a brief. Note that the brief is drawn up by or with the client and it is he who pays the designer's fees. So, the designer's primary duty is to his client and to provide him with a solution that fits that brief. Only if the client is also to be the user – as can sometimes be the case – does the designer owe a duty directly to the latter. More often than not, though, the users are not the designer's clients and so play little or no part in the formulation of the brief. Instead they are simply factors, or even functions of it. Thus they exist only to the extent that the brief allows. Sometimes they are no more than a vaguely defined, projected target or market; but even when they are precisely identified their needs are, ultimately, interpreted by the client and subsumed within his own requirements. This is often a difficult position for the designer, who may feel more sympathy for the users than for his client, or who may feel that he knows better than his client what it is that the users/buyers need or want. But then designing is so often about the resolution of conflicting requirements at all levels and designers need to develop the ability to bring this about.

So, a designer must serve his client. He will also feel that he should serve himself in the sense of remaining true to his ideals or sense of personal development – the search for personal perfection that never ends. What that means precisely then depends on how he pictures perfection –

perhaps it is the ultimate, exquisite visual refinement of form; or the greatest possible structural efficiency; or for ever pushing back the boundaries of manufacturing technique. Or it might be to understand even better the nature of the market, either by recognizing or forecasting its existence with accuracy and then being able to respond to it or even promote it.

Clough Williams-Ellis said [*The Pleasures of Architecture*, London, 1954] that 'the architect has an abstract duty to architecture besides his duty to his client'. Architects are, of course, but one species of designer and architecture but one specific kind of design; and while one should always be wary of arguing from the particular to the general, it is tempting to suppose that if what Williams-Ellis said about architects was right, then it must also be true for designers as a whole. But, as I have briefly indicated, design (insofar as it can be said to exist at all) is very much what the individual designer conceives it to be. There is certainly no objectively identifiable corpus of knowledge that can usefully be called Design and to which all designers would feel a duty to turn whatever the brief. At most there are three universal pieces of advice that all designers should heed, but which would be equally applicable to professional advisers in many other fields. These may be stated as:

1 help your client both to recognize and achieve his aims while, at the same time, ensuring that his horizons are not unduly limited;

2 share your own vision with your client but do not ram it down his throat;

3 make sure that whatever is done is done responsibly.

Nothing very earth-shattering here – it's largely common sense. However, it does raise other questions: what is meant by 'responsibly' and to whom or what should one be responsible? The main point is that you should do your best to ensure that nothing can go amiss during the processes that give rise to whatever it is you are designing; or with the result itself or with those who use or otherwise come into contact with it during its foreseeable lifetime. You also have a responsibility to yourself which is to be certain that, just as in any other aspect of your life, you are not doing something which is, in itself, unethical. Here we are teetering on the edge of a vast and unending philosophical debate, so I shall simply state my own position and leave it at that. If you can't go along with it, figure out your own solution.

If I am asked to design something which is solely, specifically and directly intended to cause any of the following, or would result inevitably or undeservedly in any one of them, I would consider it unethical:

1 death or suffering (physical or material) to any sentient being;

2 spiritual or emotional suffering;

3 pollution or other unacceptable hazards;

4 further depletion of rare resources or species.

Situations are rarely that clear-cut, of course. It could be argued, for instance, that a prison can cause both physical and emotional suffering to those inside and that, therefore, I should not design one. But against that has to be set the concept of the 'greater good' which, in this case, would mean the protection of the great mass of law-abiding people from, say, violent criminals. If a project would,

undeniably, give rise to any of the four conditions listed above, but would also give rise to countervailing and morally acceptable benefits, then a judgement has to be made. How you make that judgement will depend on your own conscience.

That, if you like, is the negative side of one's duty to one's self: the protection of one's own morals by the avoidance of certain actions. There is, though, a positive side too: 'remaining true to (your) ideals or sense of personal development – the search for personal perfection that never ends'.

Which takes us back to an earlier point: that design 'is essentially personal and cannot be taught'. It is up to the individual designer to discover his own salvation, to evolve for himself a frame of reference and to build the mountains that he must climb. For a designer to have any-thing valuable to contribute to the world it has to be this way. The alternative may well be, in Norman Potter's words [*What is a Designer: Education and Practice*, London 1969] to be a parasite: 'one of those who skim the surface off other people's work and make a good living by it' and 'who are only too numerous'. These are the very people who reduce design to a superficial concern for outward appearance; after all, that is all they have to go on. They see something, like it and determine to do the same or nearly so. They are most unlikely to know why whatever it was they liked looked the way it did: they will not know what the brief was and will not have been party to the other designer's process of decision-making. But it obviates the need for any personal sense of conviction.

There is, of course, a problem here. The painter Sir Joshua Reynolds said, in effect, that you cannot make something out of nothing – which is true no matter whether one is talking about the concrete world or the abstract. So on or from what does an aspiring designer build that sense of personal conviction? How does he identify the goals that he is aiming at? To get answers each individual needs to ask himself:

1 what people or kinds of people do I want to benefit by means of my designing and what, in any case, do I mean by 'benefit'?
2 what responsibility do I want to take for the exploiting, or otherwise, of finite resources?
3 to what extent am I prepared to struggle to reconcile questions of manufacture or production and use with those of appearance?
4 to what extent am I prepared to eschew wilful egoism?

These are not easy questions for those who are at all serious about where, as designers, they wish to go. To some extent the answers will come from within, although the views they represent may, on contemplation, need revision. The more practical aspects and indeed, the aesthetic will require some finding out which, in turn, implies a willing-ness to become informed – and to take that upon oneself. The aim is to achieve a state of personal knowledge and understanding that is, at any time, neither so shallow as to ensure mere superficiality, nor so detailed as to inhibit action completely. Thus, the interior designer needs, for example, to have experienced for himself the conscious exploration of time and space and as many as possible of the infinite number of ways these can be defined and

modified, but not to the extent that such exploration becomes an end in itself. More prosaically he should know enough about, say, joinery to be sure that what he proposes is both feasible and sensible, yet without having to be able to do it himself. And as for questions of visual aesthetics, yes of course he should extend his horizons by looking at the work of others – he cannot live in a cultural vacuum – but always with the purpose of trying to discover why other people's work looks like it does, looking for the reasons behind the appearance.

So it is not just a quarry nor a mine. Other designers' work is not there for you to lift or plagiarize. Only aesthetic parasites, with no means of their own to nourish their imaginations, plagiarize the work of others and unthinkingly adopt their outward manner – thereby reducing something that had been well-reasoned, perhaps, into a mere affectation or mannerism.

This is not the place to say any more about appearance. It is sufficient to regard it as just one of several aspects of designing and one which is by no means independent of the others. This is equally true of all the others, of course. Thus appearance, mode of production, materials are all interdependent and inseparable; all decisions regarding these three stem from the designer's brief as interpreted in the light of his own personal convictions, aims, skills and knowledge.

The purpose of this series of books, however, is not to attempt to encompass the designing of interiors in all its complexity – either from a general standpoint or in relation to specific kinds of interior. Given the variety of issues that would entail, a work of far greater magnitude would be required – and, even then, could not encompass the infinite variety of legitimate personal conviction. Of necessity, therefore, the aims have been limited to matters about which it is possible to be reasonably objective: planning and construction. Even so, neither will be found to have been removed entirely from its wider context; neither is treated as if in a vacuum or as if it were an end in itself. Nor has any attempt been made to be wholly comprehensive about either. The purpose has not been to say everything that could be said about planning or about building construction: but to say just enough about what may be permissible, practical or desirable: to say what, in principle, is possible. Which is what an interior designer really needs to know – certainly at the start of his or her career. Of course, as time goes on, a designer will seek out the more specialized information needed for this or that particular project – to be added to the background that this series provides: a general body of practical information, seen from the standpoint of an interior designer, that should be accessible to and understood by all interior designers. It is the minimum necessary to inform and balance the other aspects of the discipline.

1 Internal Planning: An Introduction

To plan is to decide in advance what goes where. It is an activity that is fundamental to the designing of interiors: thinking clearly about everything that needs to be accommodated, working out what kind of space is required and determining where things should go relative to one another. So fundamental is it that, in the great majority of interior design exercises, it comes first: only after the plan has been developed (at least in part) are other aspects of the problem considered. Indeed, there are those who would maintain that it is necessary to have gone further and to have actually completed planning before considering anything else at all, believing that if a plan is well and truly thrashed out everything else will be automatically resolved. That, in my view, goes too far. It denies the possibility of other factors affecting fundamentally the form that a building may take; and naïvely follows the erroneous dictum that form follows (i.e. results from) function. Since there is nothing, least of all a building, that can be said to have but a single function, nothing can

1 BACK STAIR
2 BAKE HOUSE
3 BALLROOM
4 BILLIARDS ROOM
5 BUSINESS ROOM
6 BUTLER
7 CELLARS
8 CHAPEL
9 DINING ROOM
10 DRAWING ROOM
11 ENTRANCE HALL
12 ESTATE ENTRANCE
13 GALLERY
14 KITCHEN
15 LIBRARY
16 MAIN STAIR
17 MEAT STORE
18 OFFICE
19 PANTRY
20 PASSAGE
21 PRIVATE STAIR
22 SALOON
23 SCULLERY
24 SERVANTS' HALL
25 " STAIR
26 SERVICE ROOM
27 SILVER
28 SMOKING ROOM

"To plan is to decide in advance what goes where."

"No matter how breathtaking … if its plan is impractical the building, or any part of it, cannot be said to be good."

possess one inevitable (and therefore somehow appropriate) form. It may fairly be said, however, that while good plans cannot actually guarantee successful buildings, bad ones rule them out entirely. No matter how breathtaking, memorable or stimulating a building, if its plan is impractical the building, or any part of it, cannot be said to be good. Such a place is a failure, because it is of no practical help to the user – worse, it may even be a positive impediment, preventing the very thing it was meant to facilitate.

Good planning eliminates all practical difficulties that might otherwise arise in the day to day use of a building. Like much else that is not easily attained, good plans are hardly noticeable because everything seems to be just where it is needed. Bad plans, however, are always glaringly obvious. Things are never where either logic or usual practice dictate that they should be. Bad plans are a constant source of annoyance to those using the building and can never be excused on the grounds that 'it looks better that way'. Of course you want the place to look good and so does your client – but seldom at the expense of practicality. However, if this makes it sound as if a choice has to be made, between appearance and utility, then I have misled you. There is no choice, there is no preference: places must work *and* look good.

Planning, then, is the internal organization of a building. It is the exercise that determines where each particular activity takes place so as to maximize the efficiency of that activity. It must also ensure the best possible relationship between any one activity and any others with which, either by virtue of practicality or logic,

it is connected. It is possible to think of that exercise as a quite separate part of the overall design process – as, indeed, we are presently doing – having its own methods and preoccupations. Yet it is unwise ever to forget the other aspects of architecture or interior design with which it has to co-ordinate.

There never is an ideal plan. There never is just one plan that can be described as perfect. Even in the simplest building there are so many factors that have to be considered and so many different ways in which those factors can be weighted; some, by their nature, are variable anyway. Consequently, there can be no such thing as an optimum plan – which is probably just as well, or the world would be more drearily uniform than it has become already. There are often hundreds of ways of planning the same building. The job of the designer is to eliminate all such possible plans that have the least utility to commend them and to discover which of the few, more practical, solutions is the best in the circumstances. In other words, he must find the plan that corresponds most closely to the *modus operandi* of his client.

Put like that it probably sounds quite straight-forward. All you have to do is to find out how your client goes about things and then use that information to determine which of the possible plans works best. Unfortunately, it is not quite that simple. Even if you can find out how your client goes about things (and this can be surprisingly difficult) there is no certainty that his methods are actually the best or the most appropriate – in which case you will be doing him no service to allow him to repeat his earlier mistakes. There may be any number of reasons

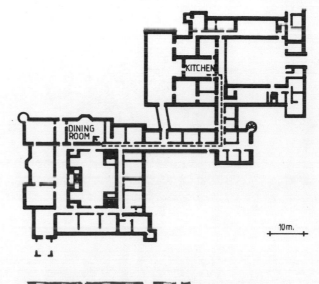

"Bad plans are a constant source of annoyance …"

"There are often hundreds of ways of planning the same building."

why something is being done in a way that is no longer entirely suitable or which will soon become so: personnel numbers can change, as can processes; regulations can become more onerous; the structure of the existing building may have dictated ways of doing things that were less than ideal but to which people have become accustomed; new technology may now exist and so, too, may new attitudes. Therefore while it is always instructive to find out as much as you can about how your client does things, you also need to discuss why and be prepared to be positively critical about what you discover. A client may, of course, be well aware of the shortcomings of his existing set-up and may already have views about how things can be improved. Here, too, you would need to be helpfully critical in case your client's views were in some way mistaken. Other clients will be aware that a problem exists and will expect you to solve it for them – which you can only do after a lot of probing.

It is a mistake, therefore, to base a new plan uncritically upon an old one. It is not impossible, of course, that an existing plan is still the best for the job, but this should never be assumed – even if your client can find no fault with it. After all, he has used it, perhaps for years, become habituated to it and may be unable, any longer, to see any of its failings.

When planning a building, either wholly or in part, it is vital to find out what it is your client wants to do – not what he thinks he wants. If you ask him, 'What do you need?', nine times out of ten he will tell you what he has got, more or less. It is a comparatively rare client who can stand back from his activities and look really critically at

how he does things – and a rarer one still who can then prescribe the appropriate improvements. But this is something that you should be able to help the other 90 per cent to do.

Good planning, therefore, depends on getting the information you need from your client – and that usually means forcing him to think far more deeply about what he does and how he does it than he ever imagined would be necessary. Indeed, there are many clients who suppose that, once they have appointed someone to design a building or its interior they can just sit back and wait for the results which, as if by magic, will be just what they want. This, of course, is naïve. Anyone who commissions an architect or interior designer and who hopes for good results will have to do his bit as well: he will need to think very hard in order to give you, the designer, the answers to your questions – and this applies not only to matters of planning. The client's job is to give you the information you require in order to understand fully what the eventual users need to do. Your job is then to plan to make this possible while, at the same time, taking into account all those other factors that your client cannot be expected to know about or to which he will not have given too much thought: building regulations, the practical limitations imposed by the building itself or its equipment, space requirements, orientation and social organization. There are also, of course, questions of psychology and aesthetics: what would it feel like if that activity occurred there and what would the place actually look like.

There are, then, numerous factors to be taken into account when deciding what goes where. Planning is not

Internal
Planning:
An Introduction

5

merely an exercise in matching requirements for space with whatever is available. You might, perhaps, have determined a need for four distinct areas of, say, 25, 50, 75 and 100m^2; and it might so happen that your building is already subdivided into four parts of exactly those sizes; but that does not necessarily mean that your planning problem is solved (although, if you are very lucky, it might be). The existing spaces may be unsuitably located in respect of one another; sunlight might enter the smallest space at the time of day when you would prefer it to enter the largest; it might be prohibitively expensive to introduce drainage into that area which, on the face of it, matched that required for kitchens and which might also prove to be furthest from suitable delivery access; and although the 50m^2 space might, on plan, accommodate the proposed activity adequately, its proportions might make it feel quite uncomfortable...

For a building to be well-planned not only must it provide the right amount of space for each of the activities that it houses, but also it must do so in an order that responds to the practical needs and expectations of all users. At the same time it must enable so much more that is so much less quantifiable: contextual relationships, aesthetic preferences, social requirements and psychological and even spiritual needs.

Thus, while there can be a somewhat mechanistic, 'jigsaw' aspect to planning, that is by no means all – if, that is, you want buildings and interiors to rise above the merely adequate, measured solely in terms of square metres.

Summary

This chapter has touched upon, in a general way, the objectives of planning. It has also made the point that, even though planning is a fundamental activity and one that almost always initiates the whole design process for architects and interior designers, it should not be seen as an isolated exercise. Questions of planning should not be solved purely on their own terms. For although planning has much to do with matters of measurement and practicality (both of usage and structure) these are not the only considerations. One should also ask 'How would this plan feel?' and 'What impact would such a plan have on the senses?'. Aesthetics and psychology cannot be divorced from planning if buildings and their interiors are not only to work but also to gratify.

For the most part, however, this book will be mainly concerned with practical objectives, particularly if the contents page is used as a kind of check list. This is, indeed, a general list of the planning considerations common to buildings and interiors of many kinds. Only the chapter on access alludes to the aesthetic and psychological effects of planning, since they are more easily demonstrable in this context. Even so, these are constant factors to be considered whenever a planning decision of any kind has to be made.

2

**The
Brief**

Strictly speaking, getting the brief is not part of planning.
It is, however, the necessary preparation to design in gen-
eral and to planning in particular. Until he has a usable
brief, the designer can do nothing; this is true even when
he is designing for himself. A brief establishes what it is one
is aiming to achieve and, unless you know that, there is not
a lot of point in starting. To attempt to design without a
brief is like setting out on a journey without a specific goal
or destination; one has no way of knowing whether the
journey was worthwhile or whether one could ever be said
to have arrived. The tourist only sets out to achieve very
general objectives – to head south, for instance, or to visit
Belgium – and thereafter his touring has no purpose other
than itself; it is a form of kinetic experience to be enjoyed
for its own sake and any discoveries en route are inciden-
tal. Contrast this with the traveller who sets out specifically
to spend September and the five ensuing months in the tiny
village of Querigut in the French Pyrenees for the purpose
of recording, by means of drawings, photographs, film and

*"…to design
without a brief
is…a journey
without a specific
goal…"*

sound recordings, the life of its inhabitants throughout the autumn and winter. While his journey to Querigut might also be enjoyable, that is by no means the criterion by which his trip will ultimately be judged.

If you sit in front of a blank sheet of paper and say 'I think I'll design something' you are like a tourist. Assuming you do, somehow, get started, all you are doing is doodling: an unfocused activity which may well be pleasurable but will only get you somewhere by accident. Even if you give yourself a little more help at the start and say, for instance, 'I think I'll design a house' you still really do not know where you are going and, unless you make many more preliminary and positive decisions about what the house is for, you may as well spin a coin every time you have to make a choice – which will be about every five seconds.

A brief, then, describes what it is you are aiming to achieve as a result of your design. Typically there are both general and specific objectives. Here is an example of the first part of a brief which sets out the general aims of a particular interior design project, based on a particular case study.

1 Convert a redundant, Gothic revival church tower, 30m high, on the coast of northeast Scotland, into a house.

2 The house will be occupied throughout the year by a family of three: Craig Kirk (35), Mary Kirk (34) and their son Laurence Kirk (3 months). No other children are anticipated but they have a 1 year-old golden labrador.

3 Space is required for the usual domestic activities: sleeping, dressing, toilet, preparation of food, eating, play, relaxing, entertaining visitors and the storage of items

"…doodling …will only get you somewhere by accident."

associated with all these activities.

4 In addition, space is required by Mr Kirk to enable him to work at home from time to time.

This gives the broad thrust of the project and one could just about get started, but the following information would be well worth waiting for:

5 The tower is a building of historic interest and may not be altered externally, although internal changes are permissible. In any case, vertical circulation is presently only by means of a series of ladders and the existing floors are all quite unsafe.

6 It is situated on a hill-top less than a mile from the coast and is visible for many miles in all directions.

7 There are, at present, no mains services – no water, electricity, sewerage or gas. Of these, all but the last can be provided. Note, however, that the level of the reservoir is only 5m higher than the base of the tower. Unless pumped, therefore, water can only be delivered to ground floor level.

8 Mr Kirk is a lecturer and writer on early musical history. He owns and plays a small but varied collection of Renaissance and pre-Renaissance instruments.

9 Mrs Kirk is a children's psychiatrist with a particular interest in the needs of children to structure their own environments. She is also a committed ecologist.

10 Although built of local stone (basalt rubble with sandstone dressings) with solid walls between 0.6 and 1.2m thick, the exposed position means that the building (though pleasantly cool in summer) will be very cold in winter. At least 100mm of insulation will be required on the inside faces of all walls.

11 The Kirks relax in three main ways: listening to recorded music and playing early music together with two or three friends, having not more than eight people to dinner (very informally) and, lastly, reading; they have a library of over 3000 books. Although there is a television, it lives in a cupboard and is taken out only occasionally for specific programmes.

There is, of course, much much more that could usefully be said about the Kirks. Nonetheless, we do now know a little more both about them and about the building that is to become their home. Already certain limitations are becoming apparent, as are some specific aims. For instance, given Mrs Kirk's interest in ecology, it is doubtful whether or not she would countenance the unnecessary use of fuel, for heating and for running a water pump. This could mean that all equipment using water would have to be situated at ground-floor level, thereby having a considerable impact on planning generally. It also underlines the need for insulation as the main means of combatting heat loss. This could, in turn, lead to a conflict regarding acoustics, since the present combination of room proportion and naked stone walls provides ideal sound quality for the kind of music the Kirks play. Clearly, the standard living room layout of two armchairs and a sofa grouped round a television is hardly going to suit this family with its music group and dinner parties for eight. Moreover, how much space is required for 3000 books?

Before actually starting to plan the interior of this conversion, the designer would need to discover a lot more about both the Kirks and their work. While some kind of design, no doubt a very exciting design, could have been

produced solely on the basis of points one to four above, it
is doubtful whether it would have been entirely appro-
priate given what points five to eleven later revealed.
Before starting to design, therefore, make sure you know
what it is you have to achieve. This does not mean
'knowing' that you need a living room or a music room or
whatever, since living rooms and music rooms and every
other kind of a room with a title are solutions, not aims. At
the start of an interior design project you have to identify
what has to be facilitated: for instance, that once a week a
group of five adults meet to play the music of Guillaume de
Machaut; or that, once a month, after dinner, eight people
like to leave the table and drink their coffee in more
comfortable surroundings. You cannot say, at this stage,
that these requirements will be best met by the provision of
either a music room or a living room. They might be, but
until you have been right through the design process and
taken into account many, many more contributory factors
you cannot know. As Chermayeff said (*Community and
Privacy*, Chermayeff and Alexander, New York, 1963),
"…'living room', 'kitchen', 'dining room', 'bedroom',
'bathroom' are all heavily loaded words that make any
number of irrelevant images spring to mind". There are
other words, too, that present similar semantic hurdles
but none really stands for anything that is, in fact,
immutable.

A brief, then, does not consist of a list of rooms;
rooms are existing solutions. They are the solutions which
have previously been found appropriate to other problems,
usually other people's. Ultimately you may find that they
serve your problems, too, but at the start of a project you

cannot be sure of that. If, therefore, the solution is to be as close as possible to the essence of the problem, the problem needs to be posed in terms of actions. It has to list all the activities that people in the building will need to be able to perform. A brief is the answer to the question, 'What will people need to be able to do in there?' The designer then asks:

'Who are these people?'

'How many of them are there?'

'What is it, exactly, that they will want to do?'

'How are these activities performed or carried out?'

'Could they be done in any other way and, if so, would that be better?'

'Will things always be done like this, or can change be foreseen?'

'If changes did occur, what effect would they have?'

In this way, the designer strives to discover as much as possible about how the building will be used and the practical implications.

If we return to the Kirks and look at accommodation for their 3 month old son, Laurence, the brief might ultimately look something like this where he alone is concerned:

1 Laurence is to have a place that is specifically his own.

2 The place must adapt to all likely uses during the eighteen years or so that he is expected to be at home. It must, therefore, be very flexible.

3 Initial functions include sleeping (both by night and by day), feeding, changing and dressing. The place must also allow safe exploration and play. Storage is required for all clothes, disposable items, toiletries, toys, bedding, etc.

4 Both the arrangement and the equipment of the place should be capable of response to the gradual increase in the child's size so that, at any stage, neither is ever out of scale with him.

5 The space must be able to accommodate changing and developing interests.

This is still pretty general and sounds like a mixture of common sense and a counsel of perfection, but that is no reason for a designer to disregard the implications. Indeed, if in the conversion of an existing building the space allocated to a particular set of functions is, in some way, unusual, or if it is smaller than might otherwise be desired, it may well be necessary to think through problems like those just listed and work out in detail how they can be solved. What if, for instance, the best available space for Laurence should prove to be a redundant T-shaped passageway with such odd proportions that standard items of furniture could not easily be used? (This is, in fact, what happened in the case study upon which this example is based, but the location and actual floor area were sufficiently good to outweigh the apparent disadvantages.) It would be necessary simply to design in advance and in detail for all likely changes over the next 18 years, so that non-standard items could be made specially. For instance, how many soft toys does Laurence have now and how many more is he likely to get? What particular interests are his parents likely to want to foster and will these have any implications for either space or equipment? Will clothes be stored when they become too small or will they be thrown out or passed on? Should the space, at all times, reveal a continuity of development or should it change dramatically at intervals? Will Laurence be encouraged to have friends to stay? Above all, given his mother's interests, how might Laurence be expected to restructure his environment for himself?

The designer needs this quality of information if he is to be able to help his client realize his, the client's, dreams or even to conjure up realizable dreams in the first place. It may not be easy to get. It requires a lot of probing and a lot of searching questions. The same question may have to be asked several times in different ways in order to get a helpful answer. The client may resent having to think hard about his activities and may feel that the designer is prying. You may even have to do precisely that: watch the client or the user going about his business. Find out for yourself how, at least at present, he goes about things. This is by no means uncommon in non-domestic situations and, where the design of houses is concerned, it is not unknown for the designer to move in with his clients for a fortnight to find out more about them. However obtained, the more pointers you can get the better the ultimate solution is likely to be. It is also a safeguard because it provides reasons for doing things that the client himself has supplied. It is less likely that, at a later date, he will turn on the designer and accuse him of being arbitrary. If he does, he can be referred to his own copy of the brief (which they will previously have agreed in writing). The designer can then gently point out that it is not unreasonable, say, to specify a retractable staircase as the only means of access to the client's private study, if he has been specifically asked to ensure that the client can get on with his work 'free from any chance of interruption'.

The picture of the designer which I hope is emerging is of someone whose first duty is not to himself but to his client. It is not altogether fanciful to liken him to a doctor, since both need to study the patient/client and then, if necessary, prescribe something to improve the quality of his life. But Clough Williams-Ellis records (*The Pleasures of Architecture*, London 1924) that, 'it was thought a great drollery that Mr Andrew Carnegie should have had, at Skibo Castle, a portrait with the inscription *Our architect yet our friend*'. This indicates that far too often the relationship between client and designer becomes less than amicable. Unless the designer is sympathetic towards his client, he will not be able to visualize what Diana Rowntree (*Interior Design*, London, 1964) called, 'the different scenes that will be played … and the number of characters taking part,' or, as Williams-Ellis put it, 'the comings and goings, the working here, the reclining there'.

Up to this point the client has been befriended, answers to a myriad of questions have, by one means or another, been gleaned from him, he has been discretely observed, and a brief has been drawn up and agreed; an initial brief, at any rate. Yet that is still not the end of the saga. The initial brief will require further amplification by the designer.

The initial brief lists all the activities the interior of your building has to make possible. It tells you how many people are involved and what they are like. It describes the pattern of the activities – their order, time and relationship to one another. Some activities may well require special provision of one kind or another and this information will also be in the initial brief. In other words, the initial brief

extracted from your client largely concerns processes: what is done by whom, when, and in what manner. You need, however, to find out more before you can start planning properly.

The further information you now need does not, except in specialized instances, come from the client. Instead, you turn to reference books, the building and yourself. From reference books you discover statutory requirements for such things as escape routes and a whole range of data about how much space is actually needed for this or that. From the building you glean information of two kinds: what may be physically practicable and what may be aesthetically possible. From yourself you obtain a general statement of aims.

What exactly you need to find out from published sources depends very much on the kind of building you are concerned with, but it pays to be thorough about those things that have a fundamental effect on planning, particularly laws designed to protect people in the event of fire or to make buildings generally safe. Regulations of this kind are by no means uniform and vary from country to country. It is the designer's job to know whether such laws exist in the country where he is working and, if so, what they are and how to interpret them. If, for instance, a space used for a particular purpose by a given number of people is required to have three escape routes, that is information that the designer needs to add to the brief. It should not be something that he discovers to his dismay two months later, thereby undoing all the work he has done thus far. (The question of legal requirements, particularly with regard to safety, is looked at more closely in a later chapter.)

*"A lot of research
has been done into
how much... space
is needed for
people..."*

The other kind of published information that is vital even at this stage has to do with the provision of space. A lot of research has been done into how much (or how little) space is needed for people to perform all sorts of activities. If, for example, you are designing a self-service cafeteria to seat 300 people you need to know right at the start that between 1.4 and 1.7m^2 are needed for every diner (information from the *A.J. Metric Handbook*, London, 1987) making a total dining area of between 420 and 510m^2. Overlook facts like these and you will later face (often when it is far too late) trying to cram far too many people into a space that is far too small or else losing them entirely in a space that is absurdly vast. In order to amplify a brief, the designer uses his reference books to check both what is actually permissible by law and also what, in the experience of others, is advisable.

The second source of additional information is the building itself. This is equally true whether the building already exists or whether it is newly projected. Whatever the case, the building has important things to tell whoever designs its interior. Conversely, the interior designer will need to elicit certain information about the architectural envelope within which he is to work. The amount and extent of that information will vary according to the nature of the project. In new buildings where, conceptually, exterior and interior are indivisible, there is almost nothing about the building's external appearance, structure, construction and services that the interior designer should not know; if an existing building is to be re-modelled internally, the designer should be fully aware of everything that is already there. Even if, as is sometimes

the case, his work is of a more cosmetic or ephemeral nature, the interior designer cannot ignore such things as load-bearing structural elements or services.

Where the designer is concerned with an existing building, he must survey it. He needs to know everything there is to know about the building's size, shape and condition. This usually involves two kinds of survey: 'measured' and 'structural'. He should do the measured survey for himself. The structural survey is usually better left to a surveyor who is experienced in such matters. How measured surveys are undertaken is described elsewhere, but the important thing is that it must be done. The purpose is to find out as much as possible about the place as it stands. Therefore, a completed survey should yield the following: accurate plans, sections and elevations, both inside and out; and measured drawings of all those details which provide the building with whatever character it may have. These should be supplemented with a comprehensive set of photographs. The reason for the designer doing all this for himself is to ensure that his knowledge of his building is as intimate as possible, and there is nothing like crawling about inside a building with a 30m tape as a means of discovering its secrets. Measured surveys are a form of detection that necessarily precedes the designer's own plotting. By surveying your building you find out what it has to give.

'What it has to give' may appear an innocuous little phrase, yet nothing could be further from the truth. Here is an old building, dilapidated perhaps, unused for several years and unlikely ever to resume its original function. To many it appears a white elephant, to others an eyesore

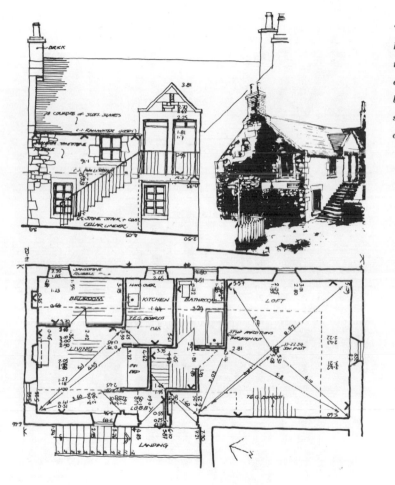

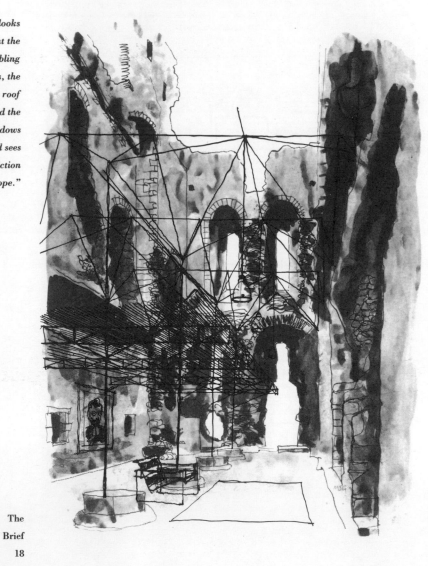

*"He looks
at the
crumbling
walls, the
gaping roof
and the
blind windows
and sees
not dereliction
but hope."*

and, to some, a worthy cause to be conserved. But to the designer it is an exciting challenge, a catalyst for ideas. He looks at the crumbling walls, the gaping roof and the blind windows and sees not dereliction but hope. Possibilities erupt and writhe within his brain, stimulated by the potential he sees locked in those sad stones. They speak to him in a language that few can understand and give him the clues he needs to assure it of a new future. That is what a building has to give, to those who understand.

New buildings are a very different bag of bricks. A new building that already exists, perhaps as no more than a shell, can be a stimulus to the imagination too. In any event, it will either require surveying or else time spent really getting to know the architect's and engineers' drawings together with a site visit. Interiors do not exist in some kind of vacuum. For every interior there is an enclosure and an exterior (even when subterranean). The designer of that interior ought to be fully conversant with both. From them he will obtain significant information with which to amplify the brief.

When a new building is still on the drawing board, the interior designer becomes, in effect, one of the building design team. In this case his role is somewhat different. Instead of there being extant bricks and mortar to which he can respond, there is nothing more than some kind of common ideal towards which all members of the team (architects, structural engineers, interior designers and others) are working together. The extent of the interior designer's responsibility within a team like this can vary considerably. His contribution may only come towards the end of the design programme and be relatively superficial;

or he may be fully involved from day one, being as
concerned as the architect is with determining the brief,
the evolution of the building's concept and its overall
planning. In the former situation decisions made earlier by
others will, of course, furnish him with some guide-lines
with which to amplify his brief; in the latter case there is
relatively little to go on at all. There are few existing
physical limitations to condition the brief further. Such as
there are stem from the nature of the site and its context,
thus providing the interior designer with an opportunity,
perhaps, to explore more extensively than usual the
possible relationships between the inside of a building and
what lies beyond. An interior designer, however, should
never ignore what lies outside. It, too, is part of the context
within which he works. In totally new buildings he can
have a better chance to help establish specific inside–
outside links, both physical and visual, as a fundamental
aspect of the overall architectural design. If, therefore, the
interior designer in such a project felt there was some
aspect of the site itself that in some way constrained his
own work, or else afforded him some tangible oppor-
tunities, such information would also amplify the brief.

 As you will have noticed, we are edging away from
hard facts. We started with dry, legal inhibitions and we
are now drifting towards conjecture. There is a difference
between the statements: 'The maximum pitch for an escape
stair in a building of public assembly shall not exceed 33°'
and, 'The clump of rowans, alders and silver birches on
the eastern edge of the site sports such a variety of small
birds that it is essential that it and they should be clearly
visible from wherever the clients shall eat'. This brings us

*"...to
explore...the
possible
relationships
between the inside
of a building
and what lies
beyond."*

to the third source of information from which the brief is amplified, the designer himself.

The designer is not merely the interpreter of requirements, whether practical or legal. He does, of course, have a duty to both of these, as has been indicated at some length. He has another duty too, or should have, and it is one that is far less easy to demonstrate because it relates not to facts but to a belief. Those who believe are the designers themselves, but it is not a common creed. It is not a creed that all designers share, nor is it one that can be emblazoned on a banner for all, whether designers or not, to follow. I cannot go along with Clough Williams-Ellis when he says [ibid], with regard to architects, that in addition to their duty to their clients they also have, 'an abstract duty to architecture'. Duty is an ethical concept, an aspect of morality and, as such, refers specifically to interpersonal behaviour. An 'abstract duty' could only be, therefore, a duty to a code of conduct or provision that governs such interpersonal behaviour.

Architecture, as far as I know, is not presented in this way and certainly not by Williams-Ellis. What he meant, I suspect, though he did not spell it out, was that there are certain veiled tenets that are universally understood by the brotherhood of architects (and by one or two other equally enlightened people) which, if observed, will ensure good architecture, whatever that is. If something of the kind were indeed true for architects, then there is no reason why there should not be something of the same kind for designers generally. Their creed, therefore, if spelt out might go something like this:

I believe in Design, an invisible and transcending

body of awareness, a secret faith to which I have the key and which I am mystically empowered to impart through my work and to which my work shall be ever bounden.

Put like that it appears ridiculous and yet many designers speak as if such words were etched in stainless steel above their futons. Nor are they entirely wrong. The creed to which they subscribe, however, is not universal, nor even generally accepted, but entirely personal. Two or more designers can still hold concurrent beliefs about what they do, but that does not make their belief any less personal. It does not establish their commonly held belief as something that is mystically extra-personal.

There is not, in fact, any such thing as Design, in the sense of a way to be followed by all those who do designing. But those people, the designers, who spend their lives proposing ways of making or doing things have personal commitments to what they do and evolve considerable personal expertise, awareness, intuition and preferences. Thus no matter how 'objective' a designer might try to be, his objectivity will always be filtered through or conditioned by his own experience and modified in the light of his own personal convictions, aims, skills and knowledge. It is quite in order, therefore, for a designer, after due consideration, to amplify his brief further to take into account his personal perceptions.

3

Zoning

Zoning is planning in a broad manner. It is an early stage of the overall planning process when decisions are made about:

1 how certain activities will be grouped together;
2 where those groups will be put.

 The larger the project, the more helpful the concept of zoning; it lets you see the wood despite the trees. It enables you to deal with broad issues before getting enmeshed in a tangled web of more detailed ones. It means that you are forced to look at the project as a whole and to seek broad general patterns that help you make sense of it all. This is very important. Clear thinking at this stage will, all being well, ensure a plan that is also clear and this is your goal. The whole purpose of planning is to make a place not only suitable for its intended use, whatever that may be, but also well defined. It is not enough that the spaces you provide for the various activities should, in themselves, be suitable. They must be located so that the necessary interaction of activities can happen in a way that

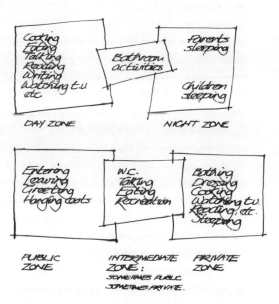

Examples of zoning.

is logical, pleasing, conforms with social usage and does not confuse. When applied to building interiors this is true of planning at any scale.

Here are some examples of what is meant by zoning:
1 People's homes, except where very small, are usually zoned. We do not, however, sit down and say, 'I think I'd better zone this place'. We do it more or less instinctively and we all do it in much the same way: we separate what might be termed the 'day zone' from the 'night zone'. The spaces that we need for such things as eating, cooking, reading, writing and watching television tend to be grouped together; the spaces that we need for sleeping also tend to be in a group, but separate from the first. Another way of looking at domestic zoning is to see a distinction between public and private areas. A 'public zone' comprising spaces where people who are not one's family can be invited and a 'private zone' for close family only.
2 In schools and colleges there are usually recognizable and distinct zones for such things as central administration, general teaching, specialized teaching (e.g. all science laboratories together), assembly and feeding.
3 In a factory there might be separate zones for such things as preparation, assembly, finishing, testing, storage, dispatch and welfare, all of which are likely to comprise several quite distinct activities or operations.

These are just three examples of zones as found in commonplace buildings. If you think about these examples you may consider that they are not all of the same kind. In the factory, for instance, most of the zones represent distinct phases in what may be a long and tedious process overall. In each factory zone there is a group of inter-related activities which together constitute a recognizably different stage in the long journey from raw material to packaged product. The practicality of production, in terms of space, time, equipment and organization requires that the factory's plan be zoned in this way. This is not true of the house however, which, despite le Corbusier, is emphatically not 'a machine for living in'. Even the best organized of us would not pretend that we behave as if on a production line and our lives are completely at odds with the kind of programmed interaction that le Corbusier's slogan conjures up. There are zones within a house, but not for the same reasons as in a factory. Where there are young children, for instance, a distinct night zone might exist in order to ensure quietness for them at times when noisy adults are still awake. In this case the justification for zoning concerns acoustics and the transmission of sound.

Reasons for zoning within buildings usually fall into one or more of the five categories that I call:
1 Linked activities
2 Like activities
3 Shared services or facilities
4 Shopping bag
5 Legal divisions.

Each of these categories is explained below.

Linked activities

Linked activities are those where, in order to do one thing, you also need facilities for another which, for entirely practical purposes, needs to be nearby. The classic example is the relationship between eating and the preparation of food, sometimes referred to as the 'dinner route'. If you consider it sensible that food, once cooked, should reach the table while still hot, the route by which it gets there should be as short and as simple as can be devised. This was not often the case in the great country houses of the eighteenth and nineteenth centuries. At Balmoral, for instance, food was taken from the kitchen by way of a covered passage within the kitchen courtyard and then past the lamp room, the coffin room, the steward's room, the wine cellar, the gun room, the huntsman's room, the butler's pantry, the ballroom passage, the plate room and the waiting room, through the servery and, at last, into the dining room. It will be noticed in this example that, apart from the inordinate distance from pot to plate (about 66 metres), facilities belonging to what ought to have been three separate zones are hopelessly confused. Today one would ensure that all those facilities connected with the preparation and consumption of food were grouped so as to benefit the main purpose of the process, not to hinder it.

Like activities

Like activities are those where, because activities are identical or else are pursued by several people simultaneously but separately, one expects to find facilities for them placed together. There does not have to be any actual causal link between them: people do not have to go from one place to another in order to achieve some overall purpose and each activity can be pursued quite independently of the others. Thus, in the changing area at the swimming baths, you expect to find all the cubicles as a group and all the showers as another group. At railway stations and airports, you do not expect to find telephone kiosks dotted about all over the place, but formed in readily recognizable groups. In an art college, if you ask directions to the painting studios you expect to discover them all in the same area, not one here and another there. Without that kind of organization the building as a whole would lack clarity and definition.

Such grouping allows the establishment of places within places which, in large buildings, can be of considerable psychological importance to the users. Thus, if you think it is important for all painting students in an art college to identify with some smaller constituent part called a department of painting, you make sure that all painting studios form an identifiable zone; conversely, if the various design studios are scattered about in odd corners, there will never be any sense of there being a department of design within the college.

Shared services or facilities

When you get a number of quite different activities which make common use of a particular service, it can make sense to zone them together as 'shared services'. The danger is that though this can make technical sense it may make no sense at all to the people who actually use the building. It is an approach, therefore, to be used with

"…you expect to discover them all in the same area, not one here and another there."

great care. Just because four particular activities all require the provision of water, for example, that is not necessarily a good reason to zone them together, though it might be. Technical expediency should never outweigh practical convenience. A good example of this category can be found in many tall buildings where lavatories usually occur in the same position on every floor so that all can share common drainage and water supply systems. This usually works well technically and is, in fact, also practical since people then know where to find them whatever floor they happen to be on.

Shopping bag

Shopping bags, at least upon one's return from the shops, contain an assortment of things. Each is in a separate package or wrapping and each is distinct. Yet together they constitute 'the shopping' or 'the messages'; all are in the same bag. There are zones in buildings that are a bit like this. Here activities are accommodated together even though they share nothing in common, other than being under the same roof. They are not, strictly speaking, interdependent; they are not alike; and they do not necessarily make use of the same services. But they nevertheless form an identifiable zone because together they constitute some larger but less easily defined activity.

The commonest example is what might be termed the 'waiting zone', particularly in certain large buildings or some types of institution. Here, once they have entered, people may make inquiries, hang up their coats, use the toilet, buy something to drink, buy a newspaper, make a telephone call, watch or listen for information and, of

course, simply wait. These activities are interdependent only to the extent that users have to enter in the first place. After that any one of them can be performed independently of the others. You can perform just one of them or all of them, it does not make any difference. All are independent constituents of what is vaguely termed 'waiting'.

Similarly, in a railway station, travellers expect to be able to buy magazines, drink coffee, get information, book reservations and wait (in comfort) all within the same zone. None of these activities actually affects, in any practical sense, any of the others: it is not necessary to buy a newspaper before you can get a coffee; nor should you have to ask the time of the next train to Edinburgh before being permitted to use the toilets. But these activities are all perceived as similar because they all relate to that phase of train travel when one is not actually getting anywhere. In much the same way, areas in a hall of residence set aside for making snacks, doing the laundry, having informal gatherings, watching television, etc., may be zoned together. Even though they are essentially unconnected they are perceived as communal, helping to promote a sense of community while at the same time belonging to it.

Legal divisions

Sometimes zoning is forced upon a building by reason of law, either statutory or religious. Mosques and synagogues, for example, require separate areas for men and for women. In the Sultan al Qaboos University in Oman (architects: YRM, London) not only do men and women have separate living accommodation, they even have separate corridors leading to lecture theatres, since the sexes must not be seen mixing in public places. In airports, customs of a different kind require the segregation not of men from women, but of domestic from international passengers, again giving rise to distinct zones. In many countries the laws that govern building employ the word 'zone' in specific ways. In Scotland, for instance, the term 'protected zone' refers to an area that is totally enclosed by non-combustible construction and which forms a very specific part of an escape route as required in certain types of building. In situations like these the designer does not have to divine a need for zones. They are forced upon him and he ought to recognize the fact in the brief itself.

Sometimes a zone is needed for just one of the five reasons described above; at other times several factors may conspire to make a zone necessary. In the average school, for example, all general purpose classrooms are grouped together and constitute a well-defined zone. On inspection it will be found that there is not just one reason for this, but two or possibly even three. First, the activities housed are linked because the daily curriculum requires that pupils (and possibly staff) move from one classroom to another between lessons with the least possible delay. Second, the activities are essentially all the same (remember, these are general purpose rooms; practical rooms are likely to be elsewhere) despite variations in the subjects being taught. They are, therefore, like activities and one would indeed expect to find such general purpose facilities all together. Third, perhaps the classrooms might also form a specific zone in order to capitalize on some

shared service or common facility. In my own school all classrooms lay to the south of two east–west corridors (one above the other) so that everyone might benefit from sunshine throughout the working day. A plan of that kind would also confer considerable structural advantage, but that in itself would not constitute sufficient reason for zoning. Construction, like services, should be employed to the best advantage of the building and not the other way round.

At the early planning stage the need for zoning will sometimes be obvious and sometimes not. Where there is an a priori requirement, whether because of law or custom, it should appear in the brief, either as obtained from the client or from subsequent modification by the designer. In such cases one knows right from the start, therefore, that zoning will be needed and one starts to plan on that basis. Even where there is no such predetermined necessity, inspection of the brief may reveal that zones are advised if the overall plan is not to become confused. In buildings housing many different activities, all of which require individual space, it will probably be necessary to divide the activities into groups before any kind of detailed analysis of their interdependence can begin, to avoid the overall problem being too unwieldy. This would constitute a form of zoning, albeit provisional, to be confirmed or amended following closer examination of the activities involved. At the very least it is a clear indicator that zones of one kind or another will be necessary, ultimately, if the building is to be intelligible to its users. For it is not enough that a building should merely work; a good building is self-explanatory. This is particularly true of buildings used by

the public where, ideally, constituent parts are both well defined and easily found. Think of the average, but unfamiliar, large department store and you will know what I do *not* mean.

While large stores are usually zoned to some extent (the departments) the definition of these zones is frequently imprecise: they overlap, are frayed at their edges or else house activities that are inconsistent with those round about them. From the retailer's point of view this may actually make sense: where zones are blurred shoppers may be tempted to buy more than they had intended. The absence of precise definition (boundaries) may tempt shoppers to wander more freely throughout the store, since, psychologically, it is all equally accessible. At the same time there is much that is, in any case, unavoidable since circulation patterns (Chapter 5) are designed to ensure that this is so.

But for the single-minded purchaser who requires specific items and for whom shopping is not a form of entertainment or leisure activity, confused zones and tortuous circulation are certainly unhelpful and may well deter further patronage.

4

Access

4.1
On Access
Generally

Zoning is largely an abstract process. It is more an idea to be subsequently embodied, an interpretation placed upon the brief, than part of the process one normally thinks of as planning. Planning, once you get down to it, is a protracted drawing board exercise. Having, by one means or another, clarified your ideas about what the plan needs to achieve, you then set about testing possible solutions by means of an apparently endless series of drawings. These should be in pencil and drawn free-hand, if the process is not to become stultified and an unnecessary exercise in draughtsmanship. Even so, they should still be to scale: initially 1:100, or if the building is large, 1:200. Large issues are dealt with first. These are the problems to which most of the others are subsidiary and usually they involve:

1 access;
2 escape;
3 circulation.

This chapter is concerned with access and the way into buildings; subsequent chapters deal with escape and with circulation.

If all that is being designed is a single bed sitting-room within existing confines, questions of circulation and access are not likely to be very troublesome. The position of the door to the room is probably fixed and the choice of routes within the room is not going to be too bewildering. If, on the other hand, a disused brewery is being converted into an indoor sports club where there will be permanent facilities for a dozen different activities, efficient circulation is going to be essential for the place to work at all. Circulation begins where people come in; it starts with access.

It may be that the point, or points, of access to a building are already determined and there is no opportunity or reason to alter them. Even with existing buildings, however, this is not always the case. Such buildings do, of course, have ways into them: but are these in the right places? It is always important to ask this question.

Impact

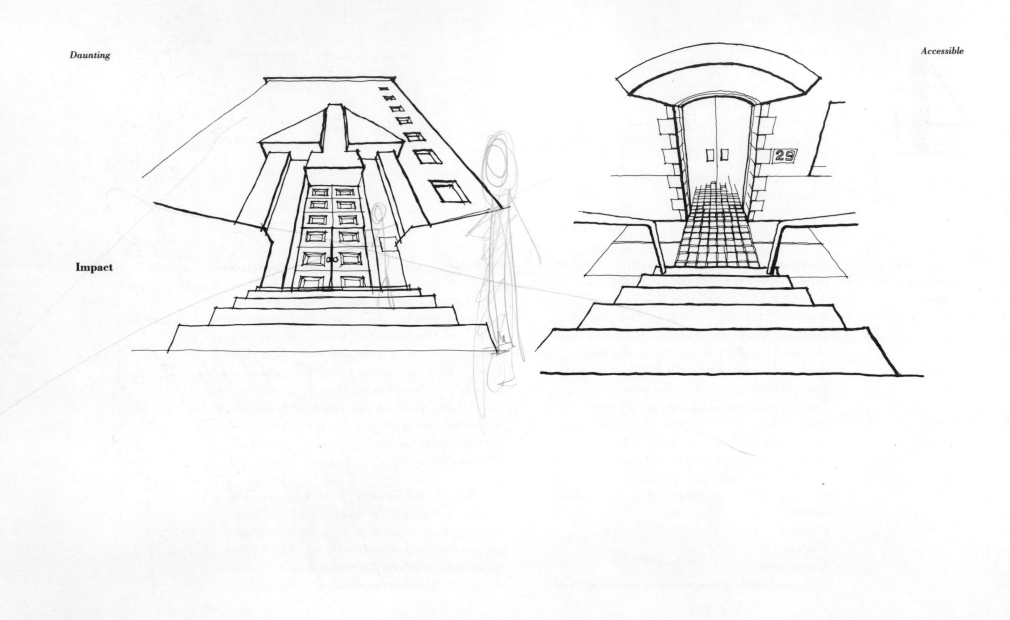

Furtive

Intriguing

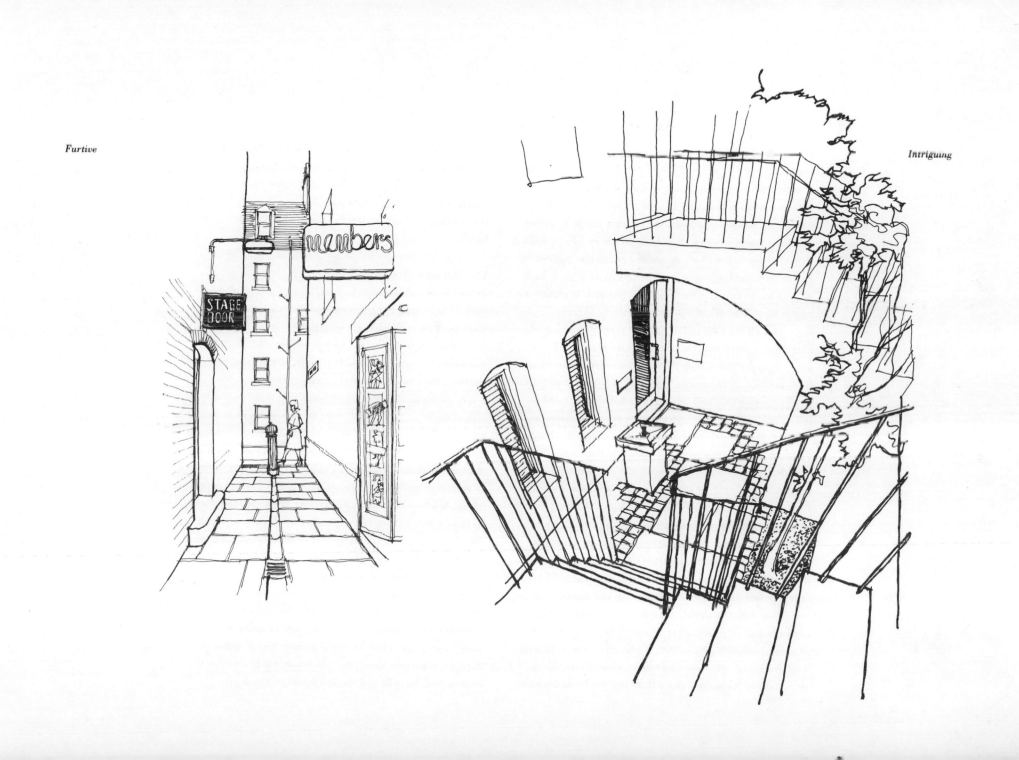

It may also be asked how it can possibly be known if the places are right or not until there is a much clearer idea of how the inside of the building will be planned. The trouble with entrances is that they face two ways: out into the world and into the building. An entrance has to be positioned so that it works well in both directions. Externally it should relate to the likely or desired pattern of approach, and to both the building's context and its own form. Internally it has to relate to the building's internal organization and to its system of circulation.

It is all too easy to fall into the trap of thinking of an entrance as something that only divides one place from another, rather than something that also connects. In addition, inside is often seen as 'positive' and outside as 'negative', implying that one side equates with 'being' and the other with 'non-being'. Certainly we do not imagine them, or respond to the ideas of inside and outside, in precisely the same ways: inside is finite, outside is not. Note, though, that the pair are not symmetrical: the one is not the reciprocal of the other. Nor are they really separate. As Gaston Bachelard has said *(The Poetics of Space*, Boston, 1964) 'the dialectics of inside and outside multiply with countless diversified nuances', meaning that the inherent contradictions between the two interact in all sorts of ways and find all sorts of reconciliation. By means of the same entrance one can enter both the house and the garden; one can go out into the world, or in out of the heat. Entrances are exits and vice versa. Yet an entrance is not just a means of access, one way or another. It plays a symbolic role too, deliberately or otherwise, and an entrance is therefore important as it contains more than just the front door.

It is worth pausing here before looking more closely at how one determines the position of entrances in order to say a little more about their meaning. After all, the fact that an entrance does mean something can be a powerful factor when it comes to deciding precisely where it should be.

The entrance as a signifier

In nearly all cultures the door possesses a powerful significance. At its simplest the door signifies transition, the movement from one domain to another. For the person passing through the door, it marks his departure from one place and his entry into another while, at the same time, it connects the two. In those so-called primitive cultures where places of all kinds are imbued with mystic or cosmological meaning, going from one place to another can be seen as a form of ritual. This is particularly true of passage from inside to outside or vice versa. It might mean no more than the shift from private to public territory; or it might be seen as symbolizing birth, death, rebirth or even copulation. Whatever the case, the passage gives external doors an importance that is duly expressed by the way in which they (and very often the parts of the building immediately surrounding them) are treated. There are any number of instances that could be used to demonstrate the 'primitive' tendency to elaborate doorways, but here are just three:

1 In the Cameroons the chiefs of the Bamileke tribe surround the doorways to their huts with dozens of carved wooden ancestor statues as signs of their divine status. The huts are of vertical bamboos, but hardwood is used for the door jambs, the sills and the lintels, all of which are

covered in figures, often life size. In addition, there are often free-standing columns, not unlike the more familiar American Indian totem poles, a metre or so in front of the doorway itself. These, too, are elaborately carved with images of the chief's forbears.

2 In New Zealand the doorways of Maori 'patakas', or village store houses, are flanked by wooden panels covered in anthropomorphic carvings to represent the various relationships between the tribe and the natural forces that control its destiny. As is so often the case with storehouses in primitive cultures throughout the world, the decoration depends heavily on the symbolization of fertility. Thus, 'among the themes depicted are the coupling of the mythic first man and woman from whom the tribe descends, as well as other sexual symbols and images such as the whale.' (*Primitive Architecture*, Enrico Guidoni, London, 1987.)

3 In Mali the mud houses (ginna) of the Dogon tribe are, in themselves, symbolic. Each represents an act of pro creation between a man and his wife. Parts of the house are held to correspond with (though they do not necessarily resemble) different parts of the human anatomy, specifically the anatomies of the couple who live there. Doors, for instance, stand for sexual organs: the one to the store room is female; the main, outer door is male.

The distinctly anthropomorphic quality of the sheath-like door openings in mud architecture serves to remind us that, morphologically, there is often a very good reason for having thicker edges to any opening: they serve to reinforce what is otherwise a weakness. The perimeters of button holes are specially stitched for exactly that reason. Likewise, there are sound technical reasons for treating the edges of doorways (and other holes in walls) differently from the walls themselves. This is particularly true where wall materials are thin or lack great inherent strength. Doorways and other openings are, therefore, potential sources of weakness. What is above the opening needs to be supported, so either arches or lintels are employed for that purpose. These, in their different ways, collect the forces that operate on them from above and redirect them to their outer ends. From these two points the forces, now concentrated, are led directly downwards by means of jambs. Structural necessity, therefore, determines that the edges of openings shall differ from the rest of the wall. Even though it would often be quite easy to disguise this fact, it is curious that man seldom chooses to do so. It is as if he needs to express clearly that the opening is not weak, that it cannot 'tear' and that it is not like a mouth without lips.

In many of the very earliest buildings a combination of physical necessity and a desire for symbolism led to the reinforcing and decoration of doorways. As civilizations slowly evolved, however, there were inevitable changes. Earlier beliefs were modified or even forgotten. New social patterns led to the replacement of relatively short-lived building materials, like rushes, timber or mud, by more enduring ones, such as stone. In their details, however, the new buildings still imitated what had gone before. Forms that had been appropriate in, say, rushes or timber were recreated in stone even though the original constructional reasons for them had gone. Thus doorways continued, and indeed continue, to be thickened at their edges just as they always have been. There are still good practical reasons for

What is its
status?

Purpose

*Who
does the
entrance
admit and
when?*

this but the idea that there may once have been symbolic reasons, too, would no doubt surprise many people.

Main entrances

Today most buildings have more than one way in or out. Of these, one is usually regarded as being more important than the others. One is usually thought of as the main entrance or the front door. Why? What purpose is served by designating one particular door in this way? There is no single answer to this but here are a few possibilities, all of which overlap:

1 It acts as a starting point from which the building, internally, unfolds itself so as to be best understood.

2 It acts as a 'frame' for the owner.

3 It confers importance on those who use it.

4 We find it easier to think of 'the' way into a building rather than just 'a' way.

5 Perhaps, subconsciously, we still feel that moving from inside to outside, or vice versa, is a symbolic act and one which, at one door at least, should be rendered ceremonial; by limiting it to just one door it is that much more ceremonial, that much more imbued with significance.

6 A building needs more than one entrance so as to permit different modes of access, different requirements for access, or different levels of consequentiality. Inevitably, the entrances would be ordered hierarchically. In such a situation, different groups or individuals might perceive different hierarchies, each with its own main entrance. Consequently, access to and from these would have to reflect not only their relative but also their individual importance.

'Main entrance' is one of the archetypes used by Christopher Alexander in his book, *A Pattern Language* (Oxford University Press, New York, 1977). He says that, 'placing the main entrance...is perhaps the single most important step you take during the evolution of a building plan'. Its position dictates people's movement both inside and outside; it affects the layout both of the building's interior and its external surroundings. For those reasons it has to be:

1 positioned so as to be immediately visible to anyone approaching the building;

2 shaped so as to be immediately recognizable.

This does not mean that it has to be immediately accessible. Indeed, it is often a good idea if it is not, so as to slow people down and give them time and space to adjust. From the moment a visitor first sights the building, however, he should have no doubt about where the main entrance is to be found.

This touches upon difficult questions of how we perceive and respond to architecture and also upon questions of architectural expression (see *Existence, Space and Architecture* by Christian Norberg-Schulz, London, 1971). It also relates to the need for goals if people are to make sense of places. As Dagobert Frey wrote: 'All architecture is a structuring of space by means of a goal or path' (*Grundlegung zu einer vergleichenden Kunstwissenschaft*, Vienna, 1949). He was not only talking in practical terms; he was also aware that, (as with other aspects of architecture) space can be appreciated in various, quite different, but interconnected ways.

Norberg-Schultz (op. cit.) effectively lists seven:

1 pragmatically or through actual use;

2 perceptually or how we as individuals variously interpret it and the assumptions that we make about it at any given moment;

3 existentially or how, in general, the individual pictures the environment, according to those invariable schemata that underlie the individual's perception about space and the ways that it is used;

4a cognitively or how we think about space and spatial relations;

4b expressively or architecturally – i.e. how we create space in order to say something about the way we understand the world;

5a logically or how we describe cognitive space in the abstract terminology of mathematics;

5b aesthetically or how we theorize about expressive space.

These can seen as a related linear series, bifurcated at one end and working in both directions. Thus, our learning starts pragmatically and through testing our perceptions we arrive at an existential view about which we think at some time or other. Some of us may go beyond that and seek to understand space theoretically; while others may also explore the other branch and attempt both to create space and to construct theories about how and why we do it. What we then understand about space affects the way we use it; so we constantly shuttle backwards and forwards along the line.

On the position and design of the main entrance

How, then, would these seven ways of appreciating space, together with Frey's observation that 'all architecture is a structuring of space by means of a goal or a path', affect the position and design of a main entrance? Is it, in fact, feasible to design for anything other than mere utility? (Cynics may wonder if even that level is more than occasionally achieved.) Since so much of our appreciation of space (and indeed all other aspects of architecture) is dependent on personal experience, intuition and reflection, the answer can only be a qualified 'yes'. Up to a point it is possible to be reasonably objective but thereafter the designer will inevitably find himself designing for himself, basing what he does upon his own personal perceptions. Not that this is necessarily a bad thing; designers, after all, might reasonably be expected to have perceptions that go beyond those of people who do not spend all their time designing. It is one of the things that he hopes he is being paid for.

At the pragmatic level, therefore, one can be quite practical. One asks questions such as:

1 Who would use the main entrance?

2 When would it be used?

3 How will users approach it; from which direction(s) and by what means?

4 Will goods or merchandise be carried through it; if so, what, how and by whom?

5 Will it need to be supervised or controlled in any way?

6 What climatic factors will affect it?

7 Are there any specific activities associated with the main entrance that would have a bearing on its design?

*How will
people
approach?*

Approach

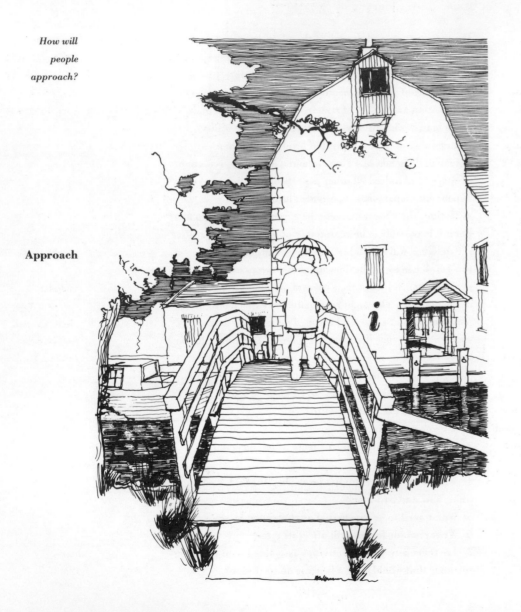

*Is the entrance
intended
for more
than one
mode of
approach?*

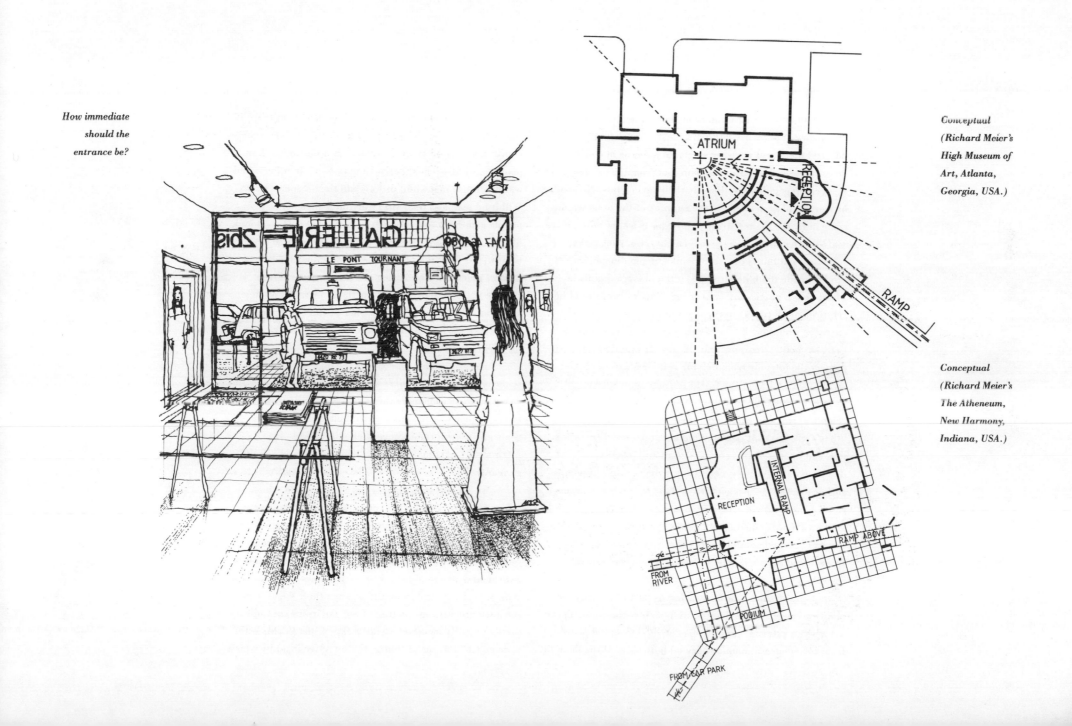

How immediate should the entrance be?

Conceptual (Richard Meier's High Museum of Art, Atlanta, Georgia, USA.)

ATRIUM

RECEPTION

RAMP

Conceptual (Richard Meier's The Atheneum, New Harmony, Indiana, USA.)

GALERIE
LE PONT TOURNANT

RECEPTION

INTERNAL RAMP

RAMP ABOVE

FROM RIVER

PODIUM

FROM CAR PARK

Thus, in a hotel it might be determined that the main entrance would be used only by guests, but at all times of day and night and arriving singly, in pairs or in coach loads. Guests might approach on foot from the car park or else be deposited at the door by their taxi or bus. No goods or merchandise needed for the running of the hotel would come in by the main entrance, but guests would both arrive and leave carrying luggage (overnight bags, rucksacks, suitcases, hat boxes or cabin trunks, depending on the kind of trade the hotel attracts) often in large quantities where coach parties are concerned. Supervision would be required at all times. In the mountains, a hotel's main entrance would need to allow people to remove climbing gear, ski boots, dripping anoraks etc. It would also have to protect the interior from driving rain or blasts of chilled air. In other parts of the world the main entrance might have to be designed to act as a cool and shady haven from a relentless sun and there are, of course, any number of other activities that go on in and around a hotel entrance that can have a bearing on its design and position: doormen call taxis, but need to stay dry; groups of people gather together before either entering or leaving; couples rendezvous; individuals wait; guests check in and out; and visitors are welcomed or bid adieu. All such practical matters can and should affect the design of the entrance. In practical terms, it is by no means enough simply to provide a large door.

Let us assume, however, that as part of a design for a main entrance a large door is, indeed, incorporated. There are also an external canopy of some kind to shield people from the elements, ample space on both sides of the door to accommodate whole coach parties and their baggage, somewhere for the night porter and so on; but we are now concentrating purely on the door. The question is: how will people, as individuals, perceive that door? In other words, what will they make of it or how will they respond to it? Will it be seen as a door that will admit them – not just people generally, but themselves specifically? Does it look like the kind of door through which they could go or would want to go? Does it look like the kind of door leading to the kind of place they think they are heading for? Can they assume that it will be opened for them, or will it open automatically? Moreover, if neither of these happens does it look like the kind of door they could, physically, open for themselves?

Everyone who approaches the door will subconsciously assess it along lines similar to these. Up to a point a designer can anticipate these questions and ensure that the door provides the answers that might be thought generally appropriate. Since such perceptions are intrinsically personal, however, there can be no absolute guarantee that his solution will be equally reassuring to all.

We do not, then, simply perceive a world which in every detail is common to every one of us, despite what naïve realists might maintain. We all perceive the world differently and our different worlds are the products of our individual motivations and past experiences. All new experiences are conditioned by earlier ones, and this is as true of architectural examples as any other. We all have our own unconscious picture of our environment built up and constantly modified by these experiences. This is the schema (the scheme of things, the set of feelings) by which

we as individuals judge all new experiences and into which we slot them. Thus, for one person, large doors may be forever associated with ideas of submission and punishment having, perhaps, spent many hours waiting outside the headmaster's study or on the steps of the law court. On the other hand, for people of a meditative disposition, given to slipping quietly into churches and cathedrals on their own, a large door might always hold out a promise of calm emanating from a belief in an other-worldly, benign control.

Even though there may be differences of detail in how individuals both respond to and use doors, there are also general patterns of response common to specific cultural groups; where these are recognized and understood, they can be taken into account in the design. Thus, large doors generally symbolize power of one kind or another. By going in, you submit to that power. By going out, you either escape it or emerge modified by it.

In this way interior designers and architects have to think consciously about entrances and everything to do with them if they believe that their work should enrich the human experience rather than merely facilitate it. It is important to recognize that people's responses to doors are of three kinds: pragmatic, perceptual and existential. Doors and all that surrounds them should therefore be designed accordingly. This is particularly true of main entrances.

Let me try to illustrate this. Imagine you are approaching a building. It is one you have not visited before. You have found your way to the right street and you have checked a couple of doors and gateways so as to figure out how the numbering system works. The place you are looking for should be further along on the opposite side. You reach a gateway bearing the number you are seeking; not that it is necessary since the sign is unmistakable. Beyond there is a cobbled courtyard across which leads a single path of much bigger stone slabs. It heads towards a small fountain which seems to be near the centre of the courtyard and then veers to the left, out of site behind a clump of trees and tall bushes. By the time you reach the fountain you can see the portico towards which the path now directs you. Since the path is quite narrow, you have to push your bicycle over the flanking cobbles, which is quite hard work. Hidden now from the gateway by the trees and bushes, the path divides around a semi-circular lawn, each branch heading towards the foot of a stone staircase. The two stairs ascend and meet under the portico. A tangle of bicycles leaning against the wall at the end of the left quadrant draws you that way. As you fix the padlock you can hear the faint noise from within and as you climb the slippery marble steps towards the large oak double doors you reflect that it is not at all as you had expected. With some difficulty, using both hands, you twist the big iron ring and the right-hand door swings slowly towards you. You step back and adjust your eyes to the soft illumination. Could this really be the cinema?

Here are examples of all seven kinds of architectural appreciation I mentioned earlier. The passage describes your *pragmatic* experience: the steps were slippery, the iron ring required two hands, etc. You reached the door through a whole series of accurate *perceptions*: you successfully interpreted such mute, expressive signals as the stone slabs set among the cobbles, the fountain as an

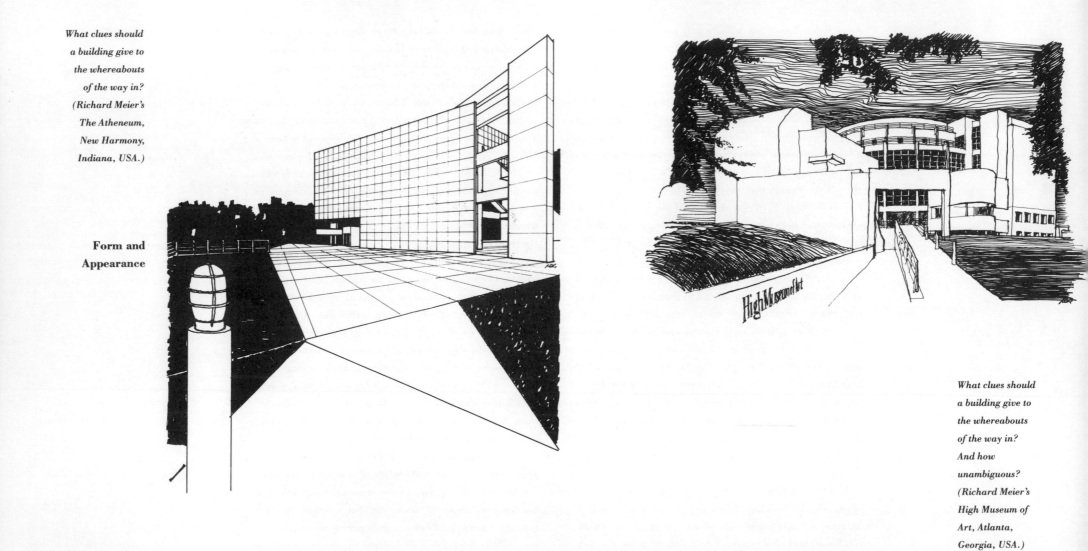

*What clues should
a building give to
the whereabouts
of the way in?
(Richard Meier's
The Atheneum,
New Harmony,
Indiana, USA.)*

**Form and
Appearance**

*What clues should
a building give to
the whereabouts
of the way in?
And how
unambiguous?
(Richard Meier's
High Museum of
Art, Atlanta,
Georgia, USA.)*

*What clues
should a
building itself
give to the
way in?*

(Russian Church)

(Japanese Temple)

*(Castle Drogo,
Devon, England:
Sir Edwin
Lutyens)*

*(Little Thakeham,
Sussex, England:
Sir Edwin
Lutyens)*

intermediate goal, and the steps. *Existentially*, however, your experience was confusing: while aspects of the external environment conformed with your general picture of how routes in general work, neither that particular route nor its actual destination corresponded at all with your schema for a cinema. The location, as described, *expressed* not cinemas but something much less commercial – a library or a college building perhaps. For me to have written this passage at all, and for you to have understood it, depends on our *cognitive* ability – our ability to think about such matters in the first place – and also our *logical* understanding of such abstract mathematical terms as 'semi-circular' and 'quadrant'. By locating the fountain near, but not at, the centre of the courtyard I was subscribing to two *aesthetic* theories: that routes need intermediate visual goals if they are to be enjoyable; and that items such as fountains placed at or near the centre of courtyards increase their attraction and so make them livelier.

The purpose, so far, has been to illustrate something about the complexity associated with ways in and out of buildings. Not only do entrances have to permit a whole range of related activities over and above those of merely entering and leaving, but entering and leaving are themselves capable of being charged with meaning, as are buildings themselves.

The illustrations throughout this chapter show some of the forms entrances may take and their relevance to planning. The considerations affecting the positions and forms of entrances are:

1 impact;
2 purpose;
3 approach;
4 form and appearance of the building itself;
5 the building's pattern of internal circulation.

Each of these implies not one but a number of questions namely:

Impact

1 What effect should the entrance have on regular users? How should it make them feel?
2 What effect should it have on visitors? How should it make them feel?

Purpose

1 Whom or what does the entrance admit?
2 When is it used?
3 What is its status? How important is it relative to any other entrances? Alternatively, how important are its users compared with those employing any other entrances?

Approach

1 How will people approach: on foot, by car, or by some other means?
2 Is the entrance intended for more than one mode of approach?
3 How immediate should the entrance be? In other words,

how quickly should one be able to gain access to the
building once it, or its site boundary, has been reached?
4 What is the effect of the topography or of any other
external, contextual relationship, whether natural, man-
made or even conceptual?

Form and appearance of the building itself
1 What expectations should one have of the entrance,
given the building's general size and appearance? In other
words, what clues should the building give about the
whereabouts of the way in?

The building's pattern of internal circulation
1 Where should the entrance be in order to gain access to
the interior in the most effective way?
2 How does the logic of the internal circulatory pattern
affect the position of the entrance?

It should be apparent that while impact, purpose and
approach all have an unambiguous effect on the form and
position of an entrance, the effect of the other two factors
is less clear-cut. A building's form, appearance and
internal circulation not only affect the entrance but are, in
turn, affected by it. The way in which an entrance is
positioned and treated may well have a considerable
influence on the building's appearance and utility.

5

Circulation

The walk across the courtyard described in the previous chapter is an example of circulation. The word refers not only to the routes that allow people to get from one place to another but also to the actual use of such routes. It is not, of course, only outdoors that circulation occurs. Just as efficient motorways and railways are needed to permit movement around the country (while towns and villages depend for their social and economic well-being on an intricate network of streets and footpaths) buildings can only work well if their internal circulation is properly thought out.

In the early stages of planning a building the designer works out what facilities need to be close to each other; in other words, he decides which activities are so interdependent that they can only be carried out properly if the spaces allocated to them are next to one another. Without such organization any building is impractical. The more often people need to get from one space to another, the closer those spaces should be. Thus, in small buildings there may not need to be any circulation space at all, as such. It may be possible to plan spaces so as always to be right next to those with which communication is most frequent. In well planned small buildings, corridors and lobbies can often be eliminated. But this is not the case in large buildings. Here, the inevitable complexity of organization (various, more or less separate, groups of interdependent activities) means that space has to be given over just to enable people to move about the place. On occasion they will, in fact, have to go from one department to another; more frequently they will want to make use of facilities that are common to all. In addition they will always need to be able to get to and from their own areas or departments without crossing the boundaries that define groups or areas to which they do not belong.

It might be thought, therefore, that circulation space performs two roles: it allows movement between relatively remote areas; and at the same time, it helps to define them. This is, indeed, often the case. However, it can be argued

*"In well-planned
small buildings,
corridors and
lobbies can often
be eliminated."*

*(Terraced house
in Holte,
Denmark, by
Palle Suenson,
1954.)*

*(Mies van
der Rohe's
'Farnsworth
House', Illinois,
1950 – a week-end
retreat.)*

BEDROOM BEDROOM

BEDROOM BATHROOM

0 1 2 3m.

1ST

GROUND

LIVING ROOM ENTRANCE &
DINING ROOM

TERRACE

C'B'D KITCHEN GARDEN

0 1 2 3m

that it should do more than that. It should not merely
locate different parts of a building and allow people to
reach them, but it should act as a social space as well.
This idea will be looked at more closely a little later.

Meanwhile, consider the inside of a relatively large
building. It houses a variety of activities that naturally
form small groups or clusters, but where each cluster is
more or less independent of the other clusters. People
working in one cluster will only occasionally have cause to
visit other clusters; or perhaps only people at certain levels
(managers, say, or tea ladies) need to cross from one
cluster to another. Visitors, however, may need to be able
to get to any part of the building, as will those whose
concern is the running and maintenance of the building as
a whole. A building like this will require two categories of
circulation:

1 within the clusters;
2 between the clusters.

Very broadly, circulation within the clusters can be
regarded as private and that between the clusters as
public. The requirements of the two are quite different.

In an article entitled 'A City is not a Tree' (*Ekistics*
No. 139) Christopher Alexander shows that by setting out a
city as a pattern of quite distinct areas and by linking these
separate areas with a road pattern organized like a tree,
circulation becomes easy to understand. The author
describes a main stem giving access to branches which, in
turn, lead to lesser branches and thence to leaves (or, if
you prefer, a main street giving access to secondary streets,
in turn leads to side roads and thence to individual
districts). One thing literally leads to another.

"...circulation:
1 within the
clusters;
2 between the
clusters."

While route-finding is quite easy, actual circulation is not, since congestion must inevitably increase towards the centre, through which all routes must pass.

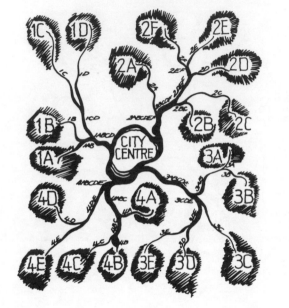

The only way to reach the twig is from the branch and the only way to the branch is off the trunk. A linear arrangement such as this has the virtue of being easily comprehended and the principle of the pattern is easily grasped. Applied to urban design it would mean that there would only ever be one way from the city centre to reach any given place on the periphery.

The same approach could be used to plan large buildings. From the main entrance a central court could give access to a series of radiating corridors from which, in turn, numerous minor passages could lead to the most distant parts. Yet, as Alexander points out, though the idea of such an arrangement is simple to grasp, in practice it is far from ideal.

There are at least two objections to designing cities as if they were trees. First, by allowing only one possible route between any two points in the system (which is effectively what the tree pattern does), moving about the city becomes a very impoverished activity. Only by going to places you do not actually want to visit and then back-tracking can you introduce variety into finding your route. Second, the route from a place on one branch to anywhere on another will always be via the trunk, which may not only be lengthy but also means an excess of traffic at the centre of the system. Yet, throughout the world there are many examples of conurbations, cities, railway systems and, of course, buildings planned in this way. Although tree-like systems are easy to comprehend and the people using them are less likely to get lost, people also find them less intrinsically interesting.

For Alexander, it is this lack of what he terms

'richness' that is the biggest indictment of tree-like urban layouts. Choice of route is either limited or non-existent. Thus, one of the simplest ways of enjoying a city is removed and so is a whole area of personal decision-making. It is not possible both to explore and to move constantly towards your objective simultaneously. It is not possible to vary your route to work every day of the week and yet set out and arrive at the same times each day. The individual is processed by a predetermined system and cannot really be said to be in control of his own movement at all.

The alternative is what Alexander calls the 'semi-lattice'. By this he means an altogether more complex way both of thinking about the city and, consequently, of organizing it. It depends on the idea that no part of a city, nor any one part of a part, is separate or wholly distinct. Every part overlaps another part; each overlap is, in itself, another part. Between all parts there is a multiplicity of routes. This is as much a way of describing many existing towns and villages as a recipe for designing new ones. Indeed, it describes the kind of towns and villages which cannot be said to have been designed at all, in the usual sense, but which simply evolved over a period of time. Such places are the result not just of one man's vision but of the many and varied requirements of hundreds, possibly thousands of people over a very long time. It is hardly surprising, then, that the places they have bequeathed us have a richness no new town can match – particularly since so few new towns are planned to be anything other than tree-like.

What does all this have to do with the planning of buildings and the patterns of circulation inside them?

"Objections...to cities...as trees: only one...route between any two points...an excess of traffic at the centre of the system."

*"And between all
parts there is a
multiplicity of
routes."*

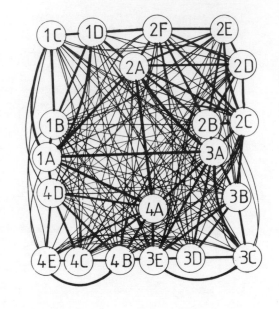

I think it enables us to pin-point two apparently conflicting requirements:

1 easy route-finding for visitors and strangers;
2 built-in choices of route for regular occupants.

Few buildings, if any, are completely analogous to cities. Even the biggest shopping malls only represent certain commercial aspects of city life. Other buildings are even more specialized, usually much more so. Given, therefore, the inherent specificity of nearly all buildings, trying to overlap activities in the way described by the semi-lattice would often mean that none of them could be pursued successfully. This is not always the case. One of the easiest traps for designers to fall into, particularly student designers, is the unthinking compartmentalization of activities. This arises most often from a failure to recognize that your building must accommodate activities. In the design of houses, for instance, it is all too easy to assume that what is needed is a lounge, a dining room, a kitchen and three bedrooms – six specific compartments – rather than space for two adults and two children to prepare food, eat, relax and sleep. Interior designers and architects should always be alert to the possible overlap of activities; that is, to the possibility of more than one activity going on in any given space. For unless there is an overriding requirement for security, silence, or some other isolating quality, spaces in which more than one activity are meant to occur are inherently 'richer' than those dedicated to one only. Almost any-where, for example, is preferable to the kind of room usually intended solely for practising musical instruments.

Returning to the question of circulation, there are two broad requirements which, on the face of it, are contradictory. Routes around the interior of large buildings should be straightforward and direct for the benefit of visitors. At the same time, they should allow a rich variety of choice to the building's regular users. This is actually quite easy if one thinks of the circulation pattern as a hierarchy, having what can be termed 'main roads', 'secondary roads' and 'lanes'; though not, of course, in a tree-like configuration. The real conflict for the designer is not in reconciling these different strata of circulation with one another, but in reconciling the notion of anything other than practicality with the question of cost. Those who commission buildings may feel it unnecessary for the building's users to do anything other than find their way about with the utmost speed and efficiency; they may see no reason at all why people should actually enjoy using the place. Somehow, the message has to be conveyed that a circulation pattern is doubly useful if it not only gets you where you want to go, but also makes you feel better in the process.

A hierarchical pattern works like this: from the main entrance, main roads or arteries radiate to distant parts of the building. They do not pass through any identifiable section of the building; for example, they do not bisect the finance department, nor do they cut a swathe through the library. Main roads lead only to junctions with other main roads. In so doing, they define the edges of the areas they skirt. As for the junctions, these are purely junctions between main roads; secondary roads and lanes do not emerge here. Thus, the system of main roads is kept distinct from the other road types. Its purpose is simply to

Barrier nursing ⇑
Central treatment ⇑
Children's wards ⇑
Day ward ⇑
Delivery ⇑
Emergency ward ⇑
General wards 1-9 ⇑
Gymnasium ⇑
Gynaecology ward ⇑
Maternity ward ⇑
Special baby care ⇑

"Routes around the interior of large buildings should be…direct for visitors. At the same time they should allow a rich variety to…regular users."

expedite movement generally around the building following a pattern that is easily recognizable. Ideally, main roads are not only large but also detailed and finished in a distinctive manner. Even more important, their routes should explain clearly the building's overall plan and, therefore, its organization. There should be frequent, unambiguous clues indicating where one is relative to the entrance and to the outside generally.

Secondary roads emerge into main roads anywhere other than at the principle junctions. They lead directly to the most important part of any particular area. For each area a secondary road should lead to its heart from each of its main boundary roads. Thus, the centre of any area can be approached from several directions. It should never be possible to confuse secondary roads with main roads. They should not only be narrower but also detailed and finished in a way that further marks them as different. It should be immediately evident to anyone joining a secondary road that they are no longer on one of the building's main arteries.

Regarding the lanes, they too should be easily recognizable as: the narrowest, by far the most intimate and clearly private. The lanes are purely for the locals, the people who ordinarily inhabit the building or that particular part of it. Visitors should not feel encouraged to make use of the lanes. Unlike main roads and secondary roads, lanes are not signposted. They emerge anonymously into both kinds of larger road anywhere except at major junctions. They may be planned that way or they may simply come about because of how the building is used.

The result of this kind of building layout is that visitors can reach their destinations quickly and without confusion. So, too, can regular users if they choose. Alternatively, they can benefit from the network of 'lanes' and experience the place in a far more varied and, therefore, richer way.

At this point, it will be helpful to change the analogy. Instead of seeing the large building as a landscape criss-crossed with motorways, secondary roads and lanes, see it as a miniature city. There is a similar hierarchy of streets, including main streets, side streets and passageways. There are also far more people. Consequently, city streets are inherently more social than country roads. Large buildings are much the same. Just as city streets perform a dual role (both enabling people to get about and acting as public spaces) so too do the circulation spaces that thread their way through schools, office blocks, hospitals and the like. Yet how many such buildings afford the equivalent of the square and the fountain; or the bench under a blossoming chestnut tree; or the low wall (that is just right for sitting on) and which overlooks the canal? In other words, where are the equivalents of those elements of civic design that can make some cities pleasant both to explore and to live in? Where can people meet, even in just twos or threes? Where is one encouraged to pause?

The kind of building layout I indicated earlier goes some way towards a solution. The junctions between main roads function as natural meeting points, particularly as nothing else happens there, providing you do not make them so huge as to make them look permanently deserted. The main roads meet and so, too, do the people who use them. It is the designer's responsibility to ensure that such meeting can occur pleasantly and comfortably; that it is understood that such junctions are actually intended for meeting and pausing; that they are social spaces which can be possessed.

*"It should never
be possible to
confuse secondary
routes with main
routes."*

*"The junctions
between main
roads function as
natural meeting
places."*

Circulation

54

The spaces provided for people to circulate through buildings should not, therefore, be merely utilitarian, though all too often this is the case. We seem to give little thought to making a walk through a building a pleasurable activity in itself. Corridors of mean proportions and interminable length are all that is usually provided. One wonders if their designers have ever actually enjoyed a walk.

The following points always need to be considered when planning circulation spaces:

1 How people walk; they are not always in a hurry to get from A to B. Sometimes they saunter or stroll; often they are not alone but in pairs or small groups; or they may even promenade, walking so as to enjoy walking and to be seen enjoying walking.

2 People can meet in two ways: they may arrange to meet at a well-defined place at a specific time; or they may encounter each other accidentally and then look for somewhere to continue that encounter more comfortably.

3 Not everyone can walk.

4 The spaces themselves are capable of infinite variation so as to provide an altogether richer experience.

Not only can the different kinds of passage ('main road', 'secondary road' and 'lane') vary in their basic cross-sectional size, each can vary further within itself. Why must passages and corridors have a constant cross-section? Why can they not expand and shrink, feel narrow here and wide there, sometimes low and at other times high? What else can be done to overcome the soullessness of the ubiquitous long straight corridor? Certainly, even if a corridor is long, ways can be found to disguise it, by

"Corridors of mean proportions and interminable length…"

*"What else can be
done to overcome
the soullessness of
the ubiquitous
long straight
corridor?"*

means of generous proportions; intermediate goals; the
play of light and shade; or an unexpected event such as a
fleeting glimpse of the outside world. The whole character
of a corridor can change within its length. Somewhere
smooth and crisp can give way to an area of indoor
greenery and then revert to its original crispness. Stately
walls can give way to an arcade. Corridors can sometimes
emerge from their confines and become bridges, balconies
or even cuttings. Such variations also bring about differ-
ences in acoustic quality (as can changes in floor finish),
thus affording further diversity. The occasional splash of
bright colour is no substitute for the more fundamental
intrinsic modulation I have been suggesting.

5.3
Stairs

Stairs, too, are an essential ingredient of circulation. On the whole one more often encounters a pleasing staircase than one does a pleasing corridor, but not all that often, particularly in modern buildings. Certainly a degree of discipline is required in the design of nearly every stair: structural considerations frequently dictate uniformity of size and detail throughout a stair's entire length; and fire or building regulations often exert their influence, too. The latter affect the stair's construction, size, detailing and mode of access to the levels they serve. Even so, there is considerable scope for making almost any stair more than a utilitarian device, and for making circulation between levels raise the spirit as well as the pulse rate.

A staircase is not merely a necessary evil. It should not be thought of as something that takes up an inconvenient amount of floor space and, therefore, should be wished away, shrunk, or replaced by some other form of vertical access. Nor is a stair just a species of inclined tunnel. A stair is an important architectural element, if for no other reason than it does indeed account for a considerable spatial volume. Wherever a building comprises more than one internal level, the fact that stairs will be required to connect those levels is inescapable. Furthermore, it is relatively uncommon to be able to do this safely with only a single stair: two, three or even more, depending on the size and nature of the building, are usually required. (See Chapter 9 for further information on the actual provision and sizing of staircases.) Consequently, the spatial, volumetric and structural implications of staircases have to be recognized and accepted early in the planning process.

"...there is considerable scope for making almost any stair more than a utilitarian device..."

Planning for stairs with straight flights

For the purposes of initial planning, the following formulae may be found useful in determining with reasonable accuracy how much space a stair with straight flights will occupy, including the necessary landing spaces at top and bottom. Where:

H = the vertical distance between adjacent floors
W = the width of the steps (i.e. side to side)
G = the going (i.e. the front to back depth of a single tread).

For any straight flight of stairs, having no half-landing:

$$(1.28H + 2W - G) \times W$$

For a straight flight with a single intermediate or half landing:

$$(1.28H + 3W - 2G) \times W$$

For a straight flight with two intermediate landings, the space required would be:

$$(1.28H + 4W - 3G) \times W$$

For a dog-leg stair, assuming each leg to be the same length:

$$[(1.28H/y) + 2W - G] \times 2W$$

where y = the number of component flights or 'legs'.

In the case of an open-well stair, square on plan, the formula becomes:

$$[(1.28H/y) + 2W - G] \times [(1.28H/y) + 2W - G]$$

where y = the number of component flights.

In each of these formulae, the factor 1.28 refers to a stair pitched at 38°, which is the steepest permissible in the U.K., in most instances. Note, however, that stairs accessible to the public in all buildings of public assembly, and stairs for general use in hospitals and residential institutions for the old, the young or the handicapped, should not exceed 33° in pitch. This is also true of all escape stairs in such buildings. But stairs in private houses may generally be pitched at 42° maximum. For these, the following factors may be substituted as appropriate:

1 For stairs @ 33°:1.54;
2 For stairs @ 42°:1.11.

Planning for circular stairs

Staircases that are circular in plan are not by any means the space-savers that many suppose; not, that is, if they have to comply with the regulations applicable in England and Wales or, worse, with those in Scotland. Since the calculation of circular stairs is somewhat complicated, owing to the number of variables, and because of the differences in the relevant regulations between one country and another, it is not practicable to give universally applicable formulae. Designers should, instead, refer to the appropriate building regulations or standards themselves. For guidance, however, the following examples may be useful.

Note: A dimension labelled (min) or (* max) is the minimum or maximum laid down in the relevant national building regulations for that particular item.*

England and Wales

1 Minimal spiral stair, for use in domestic situations only and to give access to no more than one room (though not a living room):

 overall diameter 1.394m + handrail

 dia. of newel / central well 0.194m

 clear width of steps 0.600m (* min)

 rise (per step) 0.210m

 going (on c/l) 0.206m

 minimum going 0.050m (* min)

 angle between nosings 30°

 landing size 90° quadrant

 treads / landings up to 0.100m thick

 headroom 2.000m (* min).

2 Minimal spiral stair for use generally in domestic situations and also certain other buildings that are not institutional nor for public assembly:

 overall diameter 1.794m + handrail

 dia. of newel / central well 0.194m

 clear width of steps 0.800m (* min)

 rise (per step) 0.210m

 going (on c/l) 0.258m

 minimum going 0.050m (* min)

 angle between nosings 30°

 landing size 90° quadrant

 treads / landings up to 0.100m thick

 headroom 2.000m (* min).

3 Larger spiral stair for use generally in domestic situations and also certain other buildings that are neither institutional nor for public assembly:

 overall diameter 2.216m + handrail

 dia. of newel / central well 0.218m

 clear width of steps 0.999m

 rise per step 0.210m

 going (on c/l) 0.280m

 minimum going 0.050m

 angle between nosings 26° 37' 17" approx.

 treads / landings up to 0.100m thick

 landing size

 (a) 93° 47' 15" segment or

 (b) 120° 24' 31" segment

 headroom

 (a) 2.210m or

 (b) 2.000m (* min).

4 Minimal circular stair to serve assembly buildings (areas greater than 100m² or accommodating more than 50 people) or for general use in institutional buildings:

 overall diameter 3.178m

 diameter of central well 1.178m

 clear width of steps 1.000m (* min)

 rise (per step) 0.135m

 going, measured

 (a) 0.270m from inner edge 0.280m

 (b) 0.270m from outer edge 0.430m

 (c) at inner edge 0.192m

 angle between nosings 18° 46'

 landings 56° 18' segment.

In England and Wales, spiral stairs may be set out according to either The Building Regulations 1985 or British Standard BS5395. The results may differ. But in Scotland, The Building Standards (Scotland) Regulations are the sole (and generally more onerous) authority. Thus, many proprietary stairs made for the English market are inadmissible in Scotland.

Scotland

1 Minimal spiral 'Private Stair' for domestic use serving a single room only (not a living room):

 overall diameter 1.522m + handrail

 dia. of newel / central well 0.322m

 clear width of steps 0.600m (* min)

 rise (per step) 0.194m

 going (on c/l) 0.215m

 minimum going 0.075m (* min)

 angle between nosings 30°

 landings 90° quadrant

 pitch (on c/l) 42° (* max)

 vertical clearance 2.050m (* min)

 treads / landings up to 0.084m thick.

2 Minimal spiral 'Private Stair' for use in domestic situations, except as in (1) above:

 overall diameter 1.956m + handrail

 dia. of newel / central well 0.356m

 clear width of steps 0.800m (* min)

 rise (per step) 0.220m (* max)

 going (on c/l) 0.244m

 minimum going 0.075m (* min)

 angle between nosings 24° 23' 28"

 landings

 (a) 91° 41' 47" segment or

 (b) 116° 5' 16" segment or

 (c) 140° 28' 44" segment

 pitch (on c/l) 42° (* max)

 vertical clearance

 (a) 2.490m or

 (b) 2.270m or

 (c) 2.050m (* min)

 treads / landings up to 0.100m thick.

3 Minimal spiral stair for use in commercial premises and hotels, etc., providing it is not an escape stair and complying, therefore, with the requirements for "Other Stairways" in regulation S4 of The Building Standards (Scotland) Regulations:

 overall diameter 1.874m + handrail

 dia. of newel / central well 0.322m

 clear width of steps 0.776m (while, in theory, a minimum width of 0.600m is permissible, this cannot, in practice, be obtained with a maximum given pitch of 38°)

 rise (per step) 0.200m

 going (on c/l) 0.256m

 minimum going 0.075m (* min)

 angle between nosings 27°

 landings 90° quadrant

 pitch (on c/l) 38° (* max)

 vertical clearance 2.050m (* min)

 treads / landings 0.150m thick.

4 Minimal spiral stair for use in residential institutions and buildings of public assembly, providing it is not an escape stair (i.e. complying with the requirements for 'Other Stairways' in the Scottish Building Standards):

>overall diameter 2.282m + handrail
>dia. of newel / central well 0.322m
>clear width of steps 0.980m (the given
>>maximum pitch of 33° precludes a stair
>>width much less than this)
>rise (per step) 0.198m
>going (on c/l) 0.304m
>minimum going 0.075m (* min)
>angle between nosings 27°
>landings 90° quadrant
>pitch (on c/l) 33° (* max)
>vertical clearance 2.050m (* min)
>treads / landings up to 0.128m thick

It is frequently asserted that in Scotland spirals may not be used for escape stairs. This is not so. It is true, however, that it rarely happens. The following examples will demonstrate why. They show that to comply with The Building Standards (Scotland) Regulations, spirals require very large overall diameters:

5 An 800mm spiral escape stair for use in buildings other than non-domestic residential premises (categories A3 and A4) or certain assembly buildings (C3):

>overall diameter 2.980m + handrail
>diameter of central well 1.380m
>clear width of steps 0.800m
>rise (per step) from 0.150m to 0.191m
>going, measured as required at
>(a) 0.270m from outer edge 0.318m
>(b) 0.270m from inner edge 0.250m (* min)
>angle between nosings 15° (* max).

6 An 1100mm spiral for use as in (5) above:

>overall diameter 3.580m + handrail
>diameter of central well 1.380m
>clear width of steps 1.100m
>rise (per step) from 0.150m to 0.152m
>going measured at
>(a) 0.270m from outer edge 0.396m
>(b) 0.270m from inner edge 0.250m (* min)
>angle between nosings 15° (* max).

7 An 800mm spiral escape stair for use in hotels and other forms of non-domestic residential accommodation (A3 and A4):

>overall diameter 3.918m + handrail
>diameter of central well 2.318m
>clear width of steps 0.800m
>rise (per step) from 0.150m to 0.202m
>going measured at
>(a) 0.270m from outer edge 0.296m
>(b) 0.270m from inner edge 0.250m (* min)
>angle between nosings 10° (* max).

8 An 1100mm spiral escape stair for use as in (7) above:

>overall diameter 6.010m + handrail
>diameter of central well 3.810m
>clear width of steps 1.100m

rise (per step) from 0.150m to 0.176m

going, measured at

(a) 0.270m from outer edge 0.348m

(b) 0.270m from inner edge 0.280m (* min)

angle between nosings 10° (* max).

9 An 800mm escape spiral for use in theatres, exhibition galleries and other such places of public assembly (C3):

 overall diameter 5.410m + handrail

 diameter of central well 3.810m

 clear width of steps 0.800m

 rise (per step) from 0.135m to 0.187m

 going, measured at

 (a) 0.270m from outer edge 0.326m

 (b) 0.270m from inner edge 0.280m (* min)

 angle between nosings 10° (* max).

10 An 1100mm escape spiral for use as in (9) above:

 overall diameter 6.010m + handrail

 diameter of central well 3.810m

 clear width of steps 1.100m

 rise (per step) from 0.135m to 0.161m

 going, measured at

 (a) 0.270m from outer edge 0.378m

 (b) 0.270m from inner edge 0.280m (* min)

 angle between nosings 10° (* max).

The examples just given are of stairs that occupy the least possible plan area (or very nearly so) while complying with the relevant U.K. building regulations. They should not be regarded in any way as standard. They simply serve to show the lower limits of what is actually possible in the circumstances given. Students, in particular, often invest spirals with near magical qualities and frequently propose staircases that are too narrow, too steep or which fail to achieve statutory minimum headroom in three-quarters of a revolution or less, thereby ruling out the provision of landings. All staircases, particularly escape stairs, need to be sized in accordance both with the specific demands likely to be made upon them and with the appropriate building codes. Where spirals are concerned, this requires special care. The number of variables that are used to determine sizes and the way they affect one another inevitably complicates the procedure. As a result, it is often necessary to test numerous possible combinations of going, stair width, rise, pitch and angle between treads until a satisfactory combination is found.

 This may sound tedious and it often is. But it may be critical. I can think of more than one instance where the entire viability of a conversion depended on a successful solution to the staircase problem. If, within a prescribed and necessarily limited floor area, a stair could not be devised that met all regulations, while attaining particular heights and levels, there would have been little point in pursuing the scheme. In cases like this exhaustive testing of hypotheses can make the difference between, perhaps, a brilliant overall planning solution, an inadequate one or even total abandonment.

A word on proprietary spiral stairs, especially those from countries other than the one in which you happen to be working. It is unwise to assume that a particular stair will be acceptable under the terms of the appropriate building regulations. Nor should you simply assume that it is capable of doing the job you require of it. A proprietary stair needs to be checked as carefully as any other.

In 'Jordan' the seventeenth century English clergyman and poet, George Herbert, asked:

Is there no beauty in truth?
Is all good structure in a winding stair?

In just two lines Herbert encapsulates the essence not merely of staircases but of good design as a whole. The two questions are in opposition and imply that neither leads to a complete answer, but that both contain an element of the truth. While there is a certain aesthetic pleasure to be derived from the apprehension of intelligible and elegant construction, that in itself is not all there is to enjoy. Thus, in an ancient spiral stair, we may easily appreciate how the keyhole shaped stone slabs have been stacked and fanned out to produce, with the aid of the encircling wall, a stair of great simplicity and directness. Yet we respond, too, to the intimacy which is the result of its proportions, to its steepness and to the continuous reassurance of the newel that both guides and connects. There has never been such an architectural device for exciting curiosity.

Elegant structure is always desirable. By this I mean structure that is, in itself, a clear, pithy and articulate exposition of the forces acting upon it and not a botch or a sham or in any way superfluous. Such structure has a beauty that is both visual and intellectual. Yet that is not enough; that in itself is not a sufficient raison d'être. Clearly the structure, whatever its purpose, has to be usable – both in a practical sense and in a way that is pleasing.

What, then, must a staircase do apart from being structurally elegant, ergonomically efficient and legal? The struggles with dimensional formulae, which concern much of this chapter, should not obscure the need for qualities for which there is no legal prescription. Perhaps a stair should intrigue and invite further inquiry; or perhaps it should allow a stately and immensely gradual progress; or else it might allow the user the illusion of secrecy. There are so many responses that stairs can be used to elicit. Which one is appropriate in a particular instance is the designer's decision. The important thing to remember is to ask the question and then to take heed of the answer. That way stairs can contribute more than they often do to the quality of circulation in buildings.

6

Safety

6.1
Introduction

Safety is easily overlooked. It is rarely uppermost in people's minds when embarking on new buildings or interiors. Clients do not, for the most part, ask specifically that their buildings should be safe. This is not because they do not want them to be safe but because it probably never occurs to them that they could be anything else. Who, after all, expects a professional to design places that are unsafe? Yet it happens.

Student projects rarely stress the question of safety. While it is not ignored entirely, it is not a subject that engenders great enthusiasm. This is not surprising. Student designers are, usually, young and adventurous. They use design projects to show what they can do, to demonstrate the extent of their imagination and to prove how exciting their designs can be. This is not wrong. College exists for this purpose. Such an approach, however, is difficult to reconcile with the caution required by safety considerations. In student schemes attention to safety is most often remedial: palliative measures taken

late in the day to offset the more glaring dangers, while trying to avoid compromise. Professional designers cannot be as cavalier as that. They are only too well aware of the requirements of building codes and the threat of law-suits, but even so safety measures frequently appear to resemble responses more than aims.

It is far better to take a positive attitude towards safety at the very start of a scheme and to identify as precisely as possible what hazards are likely to occur. The elimination of those hazards should then become part of the overall brief.

Hazards usually belong to one or more of five broad categories:

1 the building itself (e.g. there might be places from which people could fall);

2 threats posed by external sources which can, perhaps, be minimized by the design of the building (e.g. burglary);

3 hazards stemming from the proper everyday use of the building; that is where a building houses activities that, by

their nature, present risks or hazards (e.g. in workshops);
4 threats stemming from the nature of the building's users
(e.g. the old or the violent);
5 hazards arising from an emergency (e.g. fire).

Combatting such hazards is not just a matter of planning. In many cases prevention will be more a question of detailed design. This will ensure that the building's various parts and components perform their tasks properly, do not themselves pose any incidental threats in any circumstances and do not assist or exacerbate threats from other sources. There are certain aspects of safety, however, that can be positively improved by careful attention to planning.

Nonetheless it is not enough to identify the potential hazards themselves and to know how and why they might occur. It is equally important to know who it is that is threatened. Is a particular hazard likely to affect everyone in general? Or would it be certain groups of people – such as the old, the infirm or the very young – who might be at risk? Perhaps only one person, someone doing a specific job, might be in danger. Just as some groups in society may pose threats, one way or another, to the safety of others, there are other groups who are themselves vulnerable. This is always the case for the old, the very young and the handicapped, for instance. Perfectly able-bodied people can all too easily be placed at risk, too, if designers choose to ignore the possibility.

It is not possible to identify here all the hazards which might have to be addressed. Probably no two buildings pose identical problems, for no two briefs are the same, nor are any two sites. By looking a little more closely

at the five categories listed above, however, it should be possible to identify some of the more common risks.

A word of caution: there are hundreds of factors to be taken into account when designing interiors. All kinds of social, psychological, practical, physiological, legal, aesthetic, constructional and other questions have to be addressed before an apt physical solution can be proposed. All interact; each contains and is contained by all of the others. Books, of necessity, have to present such relationships in a simplified form or else risk incoherence. This one, therefore, is mainly about planning and, so, pays scant attention to other aspects of interior design or to their intimate interconnection. This should not be allowed, however, to disguise the fact that safety is not the product of good planning alone: virtually all other aspects of the subject have their parts to play too.

Unsafe materials
Unsafe materials are those which can cause death or
injury. Some building materials have been found to be
unsafe because of inherent defects; others become unsafe
because of the way in which they are used. For example:
1 noxious fumes, continuous or in the event of fire;
2 low-level radiation from granitic stone;
3 insufficient strength for intended purpose;
4 inadequate durability;
5 flammability;
6 toxicity;
7 slipperiness;
8 shininess;
9 roughness.

Inadequate structural strength
Inadequate structural stability

Inadequate structural fire precautions
These may be categorized as:
1 insufficient use of compartment walls and floors so as to
limit the spread of flame;
2 inadequate divisions between parts of a building housing
separate or distinct activities;
3 resistance to fire, both generally and in respect of
specific elements of structure, that is inappropriate to a
building of a given type and size;
4 combustibility in those elements of structure which
should be totally non-combustible;
5 incautious routing of pipes and ducts;
6 lift shafts poorly protected against the spread of fire;
7 cavities which could facilitate the spread of flames;
8 failure to identify areas of particular fire risk;
9 inappropriate use of materials.

Inadequate means of escape
For one or more of the following reasons:
1 absence of proper escape routes for use in emergency;
2 escape routes being inadequate by virtue of their
position, width, height, general design or detail (with
particular reference to doors, stairs, ramps, lobbies,
lighting, surface finishes and construction);
3 an insufficient number of escape routes relative to the
type and height of building being served and the number of
people who use it;
4 escape routes being excessively long relative to the type
of building and number of such routes.

Inadequate facilities for detecting and fighting fires
For example:
1 poor provision, location or size of windows suitable for
escape relative to the type and height of building and also
to the layout of the site;
2 restricted access to the building for fire-fighting
purposes relative to its size, height, purpose and the
number of people who use it;
3 insufficient permanent equipment (e.g. fire mains, fire
hydrants and fire lifts) according to the type, height, size
and position of the building concerned;
4 inadequate provision of devices for the automatic
detection or alleviation of fire, such as smoke detectors,
automatic ventilators and sprinkler systems.

Faulty construction or installation of chimneys, flues, hearths or heat-producing appliances

For instance:

1 chimneys containing combustible materials;

2 chimneys being inadequately jointed;

3 flue pipes being other than of iron or steel;

4 flue pipes being routed or terminated too close to combustible elements of construction or other combustible materials;

5 chimney stacks or flue pipes that are too close to other parts of the building; or which are too close to combustible roofing materials; or which do not rise far enough above surrounding roofs (according to their configuration) or nearby windows or skylights;

6 timber, other combustible material or even metal fastenings that are attached to combustible materials being too close to fireplace openings, chimneys or flues;

7 where the enclosing construction of a flue is too thin relative to the form of construction used;

8 where flues are inadequately lined;

9 where a flue is designed in a manner that is inappropriate to the fireplace or appliance it is meant to serve;

10 where the enclosing construction of a fireplace is too thin relative to the form of construction employed;

11 inappropriate location of stoves, etc., relative to walls or other parts of a building, particularly those containing combustible materials;

12 hearths that are inadequately dimensioned or detailed;

13 improperly installed heating appliances;

14 absence of fire guards.

Inadequate ventilation

Relative to the cubic capacity of each space within the building and the number of people each space is intended to hold.

The purpose of adequate ventilation in buildings is to prevent the build-up of noxious or irritating gases or particles and to avoid conditions that favour the growth of moulds and fungi. Gases, particles and fungi can all pose health hazards. Of the three, gases are the most immediately dangerous. Depending on their type and source they can produce a wide range of adverse effects on people subjected to them, ranging from headaches and nausea to poisoning or asphyxia.

There is also the possibility of explosion. It is not only the gas that fuels the kitchen stove or the central heating that poses a possible threat, although this is potentially the most devastating. All processes that rely on the burning of gases constitute a hazard, as do those that rely on the use of gases supplied under pressure. Consequently, such installations will often be governed by national codes of practice or else will require the expertise of specialist engineers. Machines or processes which give off gases as byproducts are hazards too, but they are not always recognized as such. For instance, the apparently innocuous copying machine of the kind commonly found in offices has now been implicated in cases of sickness among workers nearby. Many cleaning fluids, paints and varnishes in common use now carry warning labels stipulating that they should only be used in well ventilated areas. This warning is not very helpful if it is not actually possible to ventilate the space concerned.

Workshops generally are sources of danger and so you might think they would always receive special attention. This has by no means always been true. While there are, in some countries, national codes designed to protect workers from accidents in the workplace, their implementation is not universal. Sometimes the codes are only applicable to workshops above a certain size or where more than a certain number of people are employed. Frequently they do not apply at all to private workshops. Designers and architects do not, unfortunately, always take the time to study the processes for which they are designing; indeed, they often fail to study the process at all and simply satisfy themselves with providing so many square metres of floor space and then leaving the client to get on with it. In how many educational establishments do the woodworking facilities (which in terms of machinery may be quite lavish) have a properly designed ventilation system to prevent the inhalation of dust particles and the consequent risk of bronchial and lung disease? Only now are printmaking workshops becoming alert to the dangers of the gases given off in the etching process or in the drying of silk-screen prints. Most are still a long way from solving the problem.

Here is a final example: in the home and, more often, in caravans people have been known to asphyxiate themselves while sleeping in small unventilated spaces. In the course of normal respiration they have replaced the oxygen in the atmosphere with the carbon monoxide they themselves have manufactured.

It is not possible to give specific advice on the subject of ventilation other than to say:

1 check national codes of practice and see that they are implemented;
2 make sure you know whether or not any of the machines or processes housed in your building are the source of gases or particles that could either be irritating or toxic and, if they are, make sure that a system of ventilation is designed that is specifically tailored to the problem. It is likely that you will have to take specialist advice.

Inadequate provision of drains
Drains should ensure the hygienic disposal of sewage or other forms of foul water.

Electrical installations
These can be dangerous if for example:
1 wiring is inadequately sized, insulated, routed or installed;
2 apparatus is under-powered for its purpose;
3 there is insufficient protection against excess current in electrical circuits or sub-circuits;
4 precautions against metal becoming live are inadequate (i.e. poor earthing);
5 systems or items of apparatus cannot be readily isolated so as to prevent or minimize danger;
6 apparatus is not installed so as to positively prevent danger.

Obstruction
Danger can arise where parts of a building or items attached to it face, open or project (either permanently or otherwise) on to, over or into passages, stairs, ramps,

balconies or other places of circulation or access. Buildings and their parts should be designed free of obstruction, either permanent or potential, to people or vehicles.

Lack of information or absence of clear notices*
About, for example:
1 raising the alarm about fire or other emergencies;
2 means of escape;
3 malfunction of lifts, escalators, etc.;
4 limits to which floors, etc. may be loaded;
5 security.
*i.e. notices which are either non-existent or confusing.

Staircases
These can be a source of danger if:
1 headroom is insufficient;
2 consecutive treads are not of uniform shape and size;
3 consecutive risers are of unequal height;
4 there are not landings at each end;
5 each tread on a stair with open risers does not overlap the one below by at least 16mm;
6 they are inadequately guarded by means of walls, balustrades or railings;
7 they are inadequately provided with handrails or banisters;
8 they are too narrow relative to the kind of building and the number of people the stair is intended to serve;
9 they are too steep for the purpose, relative to the kind of building;
10 there are an excessive number of risers (3 or less is also a hazard);

11 treads are either too great or too shallow (i.e. from front to back) for a stair of that kind, relative also to the purpose of the building;
12 tapered treads (i.e. those in spiral stairs) radiate at an angle that is either too small or too great for the purpose of the stair, relative also to the purpose of the building;
13 they or the elements that enclose or guard them (in certain types of building) contain holes that could admit or trap children;
14 handrails are at an inappropriate height;
15 landings are too short relative to the type of stair.

Balconies
These can present hazards if: headings 6, 13 and 14 for staircases (above) apply.

This list, which is by no means comprehensive, only serves to alert you to the general dangers which can arise from buildings themselves. Many, if not all of these, are anticipated in the statutory building codes of individual nations, as are other dangers arising from local conditions or practices. Interior designers and architects must therefore be thoroughly familiar with the building codes of the country or countries in which they are operating. In many cases individual standards are laid down by law and these must be adhered to. As these standards are not uniform, however, varying from country to country (and being subject to periodic revision), it has not been thought sensible to try to incorporate them here. For precise information on all these and other points, please refer to the appropriate national codes of practice.

"Staircases can be a source of danger…"

Burglary and forced entry

Only the most extensive and sophisticated of preventative systems will foil the really skilful and determined burglar. Fortunately, such persons are only likely to pit their wits against worthwhile targets. Consequently, the average building is unlikely to require the same measures of prevention as, say, a bank or a safety deposit vault. Yet this does not mean that it is immune from the attention of those who, for one reason or another, might seek to break in. It therefore makes sense, even at the planning stage, to assess the likelihood of your building becoming a target for those with criminal intentions.

Here are some reasons why buildings are entered forcibly:

Crimes against people
1 assault;
2 rape;
3 kidnapping;
4 taking hostages;
5 surveillance;
6 murder.

Crimes or offences against property
1 arson;
2 vandalism (which, if unchecked, can encourage criminal activities);
3 squatting;
4 theft;
5 espionage (not only for reasons of military intelligence);
6 sabotage.

While it is hardly possible to predict exactly where particular crimes or offences will be committed, it can be shown that there are specific kinds of buildings, or certain kinds of places, where those crimes are more likely to occur. The intelligent designer tries to assess the vulnerability of his client, the building, or the building's users to the illegal actions of others. Sometimes the danger is self-evident; other times it is not. Certainly the issue should be raised at the briefing stage. It also makes sense to discuss the matter with the local police. After all, they are concerned as much with the prevention of crime as with its solution.

All buildings benefit from general planning measures and detailed design intended to deter the opportunist intruder. In planning, it is largely a matter of visibility. Increase the chance of a burglar being seen and you reduce the risk of burglary. Externally, this affects both the siting of buildings and also their shape relative to other buildings, roads, footpaths or any other kind of vantage point. A building that is well illuminated outside at night is far better defended than one that is not. The aim is to eliminate all areas that might, one way or another, provide hiding places for those with evil intentions. As a second line of defence, it may be worthwhile reducing possible escape routes to a minimum that is also consistent with the proper day-to-day function of the place.

Specific preventative measures on the building itself might include:

1 solid doors, at least 44mm thick throughout, clearly visible, equipped with good quality deadlocks (two are better than one), hinge bolts and top and bottom bolts.

All should be fixed with strong screws;

2 lockable windows fitted with laminated glass. Any window, skylight or fanlight bigger than the human head is a potential target; glass louvres are never safe;

3 burglar alarms, which act as a deterrent if visible;

4 an entry telephone system;

5 the elimination of all routes by which an agile thief could reach upper, less well-protected levels. Note that in Britain, according to the Home Office, 'the peak age for offending is 15' (*Practical Ways to Crack Crime*, Central Office of Information, 1988.);

6 surveillance cameras;

7 security lighting.

Not all buildings are as vulnerable as others; the contents are not always particularly desirable or the location may be one that is not very susceptible to crime. It is advisable to consult with the local police, whose crime prevention or community involvement section may include an architectural liaison officer, and obtain a 'crime profile' for the area.

The aim is to 'design out' the opportunity for gaining illegal entry. It may not be possible to ensure 100 per cent success, but a lot can be done by careful attention to siting, construction and details. Anything that delays the would-be offender and, thus increases his chances of being observed or heard, is useful.

Unauthorized entry

The distinction between breaking-in and unauthorized entry is that the latter does not actually involve the former. In other words, no locks have been picked; no windows

eased silently from their frames; no gratings raised in the cellar floor to admit dim figures in balaclava helmets. Instead, the offenders have simply walked in through the front door and there has been nothing to stop them. Yet they should not be there. They neither live nor work in the place. Their reasons for being there are illegal. They could be there to commit any of the crimes or offences listed earlier. It makes little sense, therefore, if you have stocked the moat with alligators, put yetts over all the windows and floodlit the entire castle if the drawbridge is then left permanently down and the portcullis permanently up. It is no use preventing illegal entry if the lawful entrances are not arranged so that only those entitled to be there can actually get in, and only when they are meant to.

An initial question, therefore, when drawing up the brief is, 'how will entrances be guarded?' This does not necessarily mean that they will be flanked by men in helmets, dobermann pinschers or, indeed, Cerberus. It is important, however, to know how people who have no business being there will be prevented. Perhaps doors will always be locked and only those with keys or electronic passcards will gain admittance on their own; others will have to knock or ring, identify themselves and then say why they have come to whomever answers. Whose job will it be to let them in. Will that person require specific accommodation or other provision? If, on the other hand, doors cannot be kept locked, will there be some kind of permanent surveillance? Will there be janitors or, perhaps, cameras; if cameras, who watches these and where?

In very large buildings, particularly those to which the public has right of access, vetting people at the door may not always be either appropriate or possible. Even so, security checks will still be required. How and when will these occur? It is essential to find out early on so that any design implications can be identified. Do not, however, fall into the trap (and this applies not only to questions of crime prevention but to all aspects of environmental design) of thinking that design can solve all problems: it cannot. Design – that is, the careful consideration of how best the things and places we use might be arranged or made – will solve or alleviate all kinds of difficulties. That is its purpose. A design solution, however, is not always the only way or the most appropriate way. Be ready, then, for those occasions when the desired improvement might more effectively stem from the reorganization of personnel or from some kind of re-scheduling, for instance. It is not always necessary to sit at a drawing board in order to find a better way of doing something.

It may become clear during the establishment of the brief that some specific, physical provision is required in order to maintain security. If, after careful consideration of all options, the need for such provision becomes evident, here are some options that could be considered:
1 permanent direct visual surveillance of all doors;
2 security cameras at all doors linked to a permanently manned control room;
3 facilities for checking the credentials of all callers prior to admittance, both on initial entry and at other points within the building;
4 security check systems dependent on such things as passcards, electronic 'keys', voice or fingerprint recognition, etc., located as above.

"...offenders have
simply walked in
through the front
door and there
has been nothing
to stop them."

Natural causes

It may seem a little odd to list 'natural causes' as a
potential source of danger to those inside a building. Yet
they can be threatening either to people in general or to
particular groups of people. There are, of course, those
maverick unexpected freaks of weather that occur once in
a while; weather that is so unusual or extreme for the area
that it could not reasonably have been taken into account
at the building design stage. For weather like this there is
no reasonable defence other than a good insurance policy.
This should not, however, apply to known areas of seismic
mobility or where intense tropical storms occur. In these
cases, natural calamities are generally predictable and are
sufficiently frequent to merit serious, protective counter-
measures in the design of all buildings. There are also
other more generally widespread natural events which,
though far less serious and dramatic than earthquakes and
typhoons, still pose threats to the safety of people indoors.
Such events occur with great frequency and are perfectly
predictable. Careful design can eliminate or, at least,
diminish their damaging effect. Here are some examples:

Glare

The sun can pose a variety of problems for those inside
buildings if sufficient care is not taken to prevent them at
the design stage. The majority of the problems have more
to do with personal comfort than with actual safety. This is
generally true of glare, but in certain situations glare
becomes a real danger. Consider the following situation.

A public building in the northern hemisphere stands
on an elevated site, rising well clear of all surrounding

buildings. All internal circulation on each of its seven levels occurs via wide corridors running north to south on the central axis. All are lit artificially and the level of illumination is fairly low. In the southwest corner of the building there is a dog-leg staircase, running east to west and connecting the southern ends of all the corridors. The staircase alone has windows; indeed, the entire west wall of the stair tower is glazed from ground level to the roof. Consequently, people going from one level to another face the windows on the first leg of either their ascent or descent. The views are spectacular, in the morning. The glare from the sun in the late afternoon and early evening, however, is so great that people are blinded as they move from the relatively gloomy corridors on to the floodlit staircase. The result, particularly for the unwary, is that people trip, collide or even fall. In an effort to provide the users of the building with a visual treat, the architect has also succeeded in committing them to an optical ordeal and has placed them at risk.

Yet this was predictable. The sun always sets in the west. Sun angles gets lower and lower as the afternoon wears on and it strikes further and further into buildings and into people's eyes. Greater attention to planning might still have provided pleasing views for those who desired them while preserving the safety of all who needed to change level.

Wind

Not all danger is as instantaneous as being blinded by sunlight and, as a result, falling downstairs. Sometimes the danger is much more insidious and it takes a long time to see its full effects. Such dangers are often much harder to recognize, or else seem so much less threatening. Wind comes into this category. The potential for wind to cause structural damage is obvious and is usually countered in the detailed calculation and design of the building structure and fabric. As for planning, possible storm damage is just one of the reasons for not siting buildings too close to trees, particularly those species with shallow roots. Much less apparent are dangers such as these:

1 doors at the bases of towers or other tall buildings. These are either liable to burst open because of positive wind pressure or else impossible to open at all because of suction (negative pressure) due to the tendency for tall buildings to exacerbate windy conditions. On exposed sites, particularly rural or coastal, careful siting is needed if entrance doors to tall buildings are not to be hazardous. This is also true in towns and cities (which are generally far less exposed to the elements than is the countryside) where tall buildings proliferate;

2 winds are by no means always fresh. They can carry sources of infection, traces of noxious substances or particles of physical irritation. If the prevailing wind blows towards your building via: a nuclear power plant; a hospital incinerator; an air conditioning plant; a busy urban road junction; a waste disposal site; a chemical plant; several square miles of barley; or any of the other things which have been implicated in the spread of illness (from asthma and asbestosis to lead poisoning, legionnaire's disease and leukaemia), it makes sense to plan and detail the building so as to prevent air infiltration from that direction. Even if you cannot protect the users of

the building when they are outside, that is no reason for not attempting to protect them when they are indoors.

Damp

Damp in buildings is unsightly and ultimately damaging to the health of those living or working there. It is also damaging to the 'health' of the building itself. In the conversion or upgrading of existing premises the elimination of existing dampness has to be a first priority. What this actually means will depend upon the building's construction and configuration. In many cases the method will ensure that the only sign of the work having been done will be the disappearance of the damp. In other cases – where, for instance, existing external walls are single leaves of stone rubble – internal spaces will shrink as new inner leaves are added. This can make all the difference to the feasibility of a scheme, particularly where spaces were tight originally.

There is also damp of a more extreme nature. While it is no doubt snug to live in the deep fold of a narrow valley, delightful to have a mountain stream plunging into the loch metres from your back door or quaint to inhabit a converted water mill, such places are liable to flooding. Only a fool would plan a building ignoring this eventuality.

Moreover, if predictions of a rise in sea level resulting from the depletion of the ozone layer are, indeed, correct, what are the implications for all the sea-coast cottages that even now are periodically inundated?

Heat and cold

Extremes of temperature are likely to be hazardous for particular groups in society. Old people, for instance, are

at risk from hypothermia if the thermometer drops too low; infants, on the other hand, are susceptible in the event of too much heat; the recovery of those who are sick is often partly dependent on being kept warm. In places where people are thus vulnerable it is usual to provide a heating or air conditioning system which is controlled thermostatically to maintain temperatures at the desired levels. That is by no means the whole story, however. The building fabric itself has to be designed to minimize any adverse effect that the temperature outside might have on the inside. In other words, the structural fabric has to combat excessive heat loss or excessive heat gain. This is usually achieved by means of integral insulation. Where the problem is of excessive heat gain only, however, it may be more appropriate to devise systems of natural ventilation which simply keep places cool.

While questions of temperature control and ventilation affect every kind of building, designers should be aware that occasionally they are not merely questions of comfort, but of life and death. In these situations it may not be sufficient simply to implement national codes of practice with regard to standards of insulation. Other measures may be required that have an effect not just on methods of construction and on the design detail of particular building elements, but on the very planning of the building.

Infestation

No one wants rats under the floor boards or mice in the bookcase. Yet vermin are an ever present hazard in some kinds of buildings. Certain areas are also known to be

permanently plagued: there are cockroaches, for example, in many parts of New York. Wherever pests like these constitute a threat to health or hygiene, it is imperative to design places that deny them the chance of getting a toe-hold. The habits and preferred habitat of the creatures has to be understood so as to build in a way that is inimical to them. This is equally true of bacteria. Places like hospitals and kitchens generally, where bacteria are likely to be present, have to be designed and detailed so that the greatest possible cleanliness can be easily achieved.

Bad luck
In some cultures luck is regarded as a very potent force and one which can actually emanate from buildings themselves. Not only can a building's shape affect the users' luck one way or another, so too can its siting and its furnishings. The Chinese, in particular, pay attention to a body of wisdom called 'Feng Shui'. This form of geomancy is used by experts (who fall into several distinct schools) first to assess a building's potential for bringing luck, both good and bad, and then to show how to capitalize on it or to avert it as may be best. Books on the subject are now available in the West.

A process may be actually dangerous, or it may be only potentially so. Either way the designer has a responsibility to limit that danger. This may entail careful attention to matters such as forms of construction, ventilation, temperature control, acoustics, choice of materials, location and space. Of these, it is the last two that have the greatest effect on planning. In the case of an inherently hazardous activity, there are two essentials: first, it should be impossible for anyone who is not routinely involved to come into contact with it; and, second, the danger should not be increased because of lack of space. As for potential hazards, they may have to be located so as to limit danger and damage, and so as to permit swift escape. Check relevant legislation and advisory documents.

The old and the infirm come into this category. They are a hazard to themselves, risking personal injury because of physical, nervous or mental impairment. Designers can limit that risk, insofar as planning is concerned, by attention to changes in level, distances and protection from anything that moves faster. Where a building houses those who are violent, the main planning requirement will be careful zoning (Chapter 3) so as to minimize the risk to others.

For **Fire Hazards** see Chapter 9.

Orientation, Daylight and Heating

7.1
Orientation

Which way should a building face? Which way should its constituent parts face? These are questions that have to be considered for each and every building and it is usually the architect that answers them. Strictly speaking 'orientation' is the positioning of a building with reference to the east point on a compass and, therefore, to all other points. It can also refer to how a building is placed relative to the site, the general surroundings or to other specific features. Certainly no building should be either positioned or angled without careful consideration of how it might relate aesthetically, practically or symbolically to all that surrounds it. It is equally important to study its relationship to the points of the compass. This is true for most cultures, though for different reasons; even within a culture reasoning may vary according to the type of building being put up.

Orientation is determined by reference to at least two sets of factors. Sometimes these correspond and sometimes they do not.

The first set comprises all those external physical factors that could, one way or another, affect decisions about which way to point a building or its parts, e.g.:
1 neighbouring buildings, trees, etc.;
2 surrounding spaces and anything they may contain,
3 established routes generally;
4 the lines of approach that are actually possible;
5 impact on the existing context;
6 prevailing wind, sun angles and climatic considerations generally.

The second set comprises all the internal factors which can also affect the question, e.g.:
1 the view out;
2 relationship to lines of approach;
3 relationship to external activities;
4 privacy or, alternatively, accessibility;
5 practical or aesthetic requirements either for or against such things as daylight, sunshine or quiet.

A third set can, less frequently perhaps, have an

effect too. Sometimes orientation is a matter of symbolism, as when Christians point the chancels of their churches eastwards (which is precisely what 'orientation' originally meant). Or else it can be the implementation of an abstract idea, such as aligning the building to an existing axis or pattern.

It is not really possible to generalize about many of these factors. Each building type, each specific building and each site needs to be tackled individually. The effect of orientation on natural illumination within buildings, however, is broadly the same for all buildings in the same hemisphere and especially at the same latitude. The reason, of course, is the sun. Thus throughout the northern hemisphere, the sun rises in the east, is in the south at midday and sets in the west. In the southern hemisphere, the sun also rises in the east and sets in the west, but at midday is in the north. The exact compass bearing at which the sun either rises or sets in any particular location depends on the location's latitude (how many degrees north or south of the equator) and on the date. The precise time and position of both sunrise and sunset vary, according to a set pattern, each day. Likewise, the sun's apparent course through the sky differs from day to day: in midwinter it describes a shallow arc of relatively short duration, while in midsummer the arc is bigger and longer lasting. Therefore, except where a building is to have no windows at all, it is important for architect and interior designer alike to know the sun's path (for that latitude) on at least two days of the year, which are the solstices. These are on or near 21 December and 22 June each year. The two very different courses taken by the sun

on these two days determine the angles, both horizontal and vertical, greatest and least, at which its light will strike the building. This information will affect both the building's orientation and its fenestration. It may well decide where a building is located on the site.

If it is intended to use part of the site for outdoor activities of any kind, it is important to determine whether it is better to pursue those activities in the sun or in the shade. This will be determined by the nature of the activity and by the nature of the climate. Thus in temperate countries, it might be thought better to be able to sit and talk in the sun; in hotter climates, sitting in the shade might be preferable. While a sunlit courtyard in Britain is likely to prove attractive and to be well used, particularly if windy conditions can be avoided, a similar courtyard in southern Spain in midsummer will be shunned in favour of shady arcades. By the careful siting and design of your building, so as to generate appropriate patterns of light or shade, you can make the surrounding area attractive and usable; do it carelessly and the surrounding area will be unused and lifeless.

Just as a garden can be rendered unappealing because of the way the sun does or does not strike it, so too can a room. The way in which the sun enters a room depends on its windows: their height, width, proportion, number, and direction; and the way in which the flanking walls are designed. None of this need be left to chance. All should be considered carefully to introduce daylight in a manner that is fitting for the space in question. In the first instance, spaces should be located within the building and also oriented to capture the sun at the times of day that are

most desirable. If, as is often stated, it is preferable to
wake in a sunlit room, it is necessary for bedroom windows
to face the east. If, as is also often stated, it is unpleasant
to cook while bathed in sunlight (cooking being a hot
activity anyway), it is unwise for kitchen windows to face
west, when the rays of the setting sun can penetrate deep
into the room. Therefore, consider the activities, consider
the extent to which they will or will not benefit from
sunshine, and locate their accommodation accordingly.

Even though a space may be ideally located, it will
not actually profit from the sun unless the windows
themselves are suitably designed. A room that is glazed
from floor to ceiling will be lit very differently from
another identically orientated room which has, perhaps,
just two small windows set in deeply splayed reveals.
Which of the two rooms is preferable would depend on
several factors, such as: latitude; time of year; exposure;
the relationship between the room and the space outside;
the view; what the room is used for; and how it is used.
Certainly a window's purpose is not merely to admit
daylight. It has additional functions – somewhere to sit, a
place for plants, a vantage point, a source of fresh air, a
solar collector (i.e. a source of heat), a link between inside
and out and vice versa – while both admitting light and
controlling it, too. Shadow is also determined, initially, by
the shape and distribution of the windows and should be
used positively, just as sunlight is.

"...a window's purpose is not merely to admit daylight."

7.30 am 9.00 am 10.30 am

noon 1.30 pm

3.00 pm 4.30 pm

Sequence showing the pattern of natural illumination on a sunny day in late March or September, from 1 1/2 hours after sunrise to 1 1/2 hours before sunset at a latitude of 52° N. Windows are south-facing and asymmetric; there is a variety of wall thickness and window detail. The consequent illumination pattern is varied.

So far, in talking about daylight, the tacit assumption has been that the sun is shining. This, of course, is by no means always the case, particularly in the U.K. Thus, although we do need to be acutely aware of how direct sunlight will effect our buildings, we have also to consider what happens when the sky is cloudy. This allows us to focus on the question: how much daylight, particularly under cloudy conditions, will actually enter this space or that? Then, there is a supplementary question: to what extent do other nearby buildings, trees or other elements of landscape further modify (either by reflection or absorption) the amount of light that gets in? In matters of orientation and window design it is not only the effects of sunlight itself that are important, but also the actual levels of illumination. In other words, how much daylight will there be? If it is cloudy and if the room in question does look out on a mature horse-chestnut tree, will there still be sufficient natural light for the occupants to pursue the activities for which the room is intended?

There is a very important corollary to these questions. It concerns fundamental decisions about the very use of daylight as a means of illumination. If a designer considers (for reasons of, say, energy conservation or the physical and mental well-being of occupants) that daylight should be used to the greatest possible extent, the impact upon planning is considerable. There are profound implications not only for the orientation of a building or its parts, nor just for the size, proportion and number of its windows, important though all these are. There are also important implications for the size, shape and location of every space within the building and for the very form of the building itself.

For a building to derive the maximum benefit from natural light, all its internal spaces (or as many of them as possible) need to be located somewhere on its periphery. Since natural light can only enter at the side or at the top of a building, that is where naturally-lit spaces need to be. The limitations this imposes on a building's cross-section should be obvious. Except where it is single-storey, a building is likely to be no more than two rooms deep. Thus a cross-section of any one level would reveal no more than two rooms, one lit from one side and one from the other. Further, the depth of each room (i.e. its measurement at right angles to the window wall) would be limited by the extent, in metres, to which daylight of sufficient strength (lux) could actually penetrate. This, in turn, would be affected by: latitude; orientation; height of windows and, therefore, of the room; overall width of window; and by the extent to which light from the sky would be reflected by both exterior and interior elements (e.g. the ornamental pond, the crematorium opposite, the ceiling, the floor, etc.).

Methods exist that enable the architect or designer to calculate, at least to some extent, the overall effect of all these factors. For many years it has been possible to buy special protractors which when applied to plans and sections show the designer what percentage of available daylight actually reaches a particular spot. More recently it has been possible to use computer programmes to do the same thing. Textbooks of a more specialized nature should be consulted for further information on calculation techniques.

Certain categories of building codes of practice may prescribe minimum daylighting provision, either in terms of lighting levels to be achieved or in terms of window area. Today, such requirements are likely to have been tempered by an awareness of the need for energy conservation. Consequently, targets are more modest than in the past. Minimum window areas may be expressed as percentages of the floor areas served so that the opportunity for uniform levels of natural illumination is the same whatever the size of the room (e.g. in Scottish houses a habitable room is required to have a total window area equal to not less than 15 per cent of its floor area). Even so, the correlation between room size, window size and potential heat loss cannot be ignored. The bigger the room, the larger the windows and the larger the windows, the greater the heat loss. Clearly, the building designer has to achieve a balance between the desire to maximize natural illumination and to minimize heat loss (both, in order to conserve energy), while at the same time relating the provision of windows and the means of heating to the size, number, distribution and use of the spaces required. The effects this can have on planning should be readily apparent and may be further intensified by the choice of heating.

Sequence showing the pattern of natural illumination between 10.30 GMT and 16.30 GMT (at 1 1/2 hour intervals) on a sunny day in late March or September. Windows are south-facing, floor-to-ceiling and positioned symmetrically.

Sequence showing
the pattern
of natural
illumination on a
sunny afternoon
in late March or
September
(at 1 1/2 hour
intervals),
through three
south-facing
windows
(symmetrically
located, in deep,
splayed reveals)
at a latitude of
52°N. The
morning pattern
would be the
same, except
"handed".

Sequence showing the pattern of natural illumination on a sunny afternoon in late March or September (at 1 1/2 hour intervals), through two south-facing windows (symmetrically located in a thin wall) at a latitude of 52°N. The morning pattern would be the same, except "handed".

The heat source that has the greatest effect on overall planning is solar power. Although there are several ways in which solar energy can be converted for architectural use, all have implications for the plan, the orientation and, indeed, the construction of buildings. Solar heating systems fall into two groups: direct and indirect. A direct system (sometimes referred to as a passive system) relies wholly on the form and construction of the building itself or its parts to capture, and then utilize, the suns rays to provide the building with warmth. It is, therefore, entirely dependent on a building's orientation and planning for its success. An indirect system, on the other hand, is not so reliant on the actual building. To a large extent it consists of mechanical components which can be either attached to a building or even stand independently; even so, such systems are optimized by attention to construction and orientation. It will be apparent that indirect systems are generally more applicable where the building to be heated already exists; but direct systems, being integral with the building, are easier to incorporate in new construction. Other power sources, such as wind, gas, oil, electricity, or coal do not in themselves affect the form that a plan takes. Where they are employed to provide visible radiant heat, however, the spaces thus heated are required to be of a suitable size and shape if any kind of efficiency is to be achieved. (There is more on this at the end of the chapter.)

Solar heating systems
It is still popularly supposed that it is only those places with clear skies and plenty of sun that can employ solar heating systems. This is not so. Even when diffused by cloud, solar energy still reaches earth and can be utilized. As to whether or not solar heating is an economically viable proposition, it rather depends on what factors you include in the equation. In any case, it also raises the question, 'economic for whom?'.

Passive solar heating systems without storage
Passive solar heating systems are of two kinds: those that allow the heat gained from the sun to be stored for later use and those that do not. At the lowest level of complexity is the window itself. Properly managed, a south-facing window (in the northern hemisphere) can be a source of annual net heat gain, rather than net heat loss, as is more often the case. This however, has more to do with the detailed design of the window, its appurtenances and their joint control than with planning. The simple window-box collector, on the other hand is of greater interest since any decision to make more than a token use of this system would have implications for both the orientation and the plan of the building concerned.

Window-box collector
This is no more than a clever device to increase the collection area of a window without, at the same time, increasing the window's liability to heat loss at night. The collector is simply a flat, multi-layered panel, sealed on three of its four edges and fitted to the outside of the building so as to allow the passage of air between itself (via the unsealed fourth edge) and the building's interior and vice versa. The collector is usually fitted immediately below a window from which it slopes down and away. The

panel's layers are as follows, starting from the top: glass, upper airspace, black metal plate, lower airspace, insulation, base. The two airspaces interconnect at the lower edge of the collector, across its full width. Sunlight passes through the glass and strikes the black metal plate by which it is then largely absorbed. The plate then warms the air that surrounds it which expands, becomes less dense and rises through the upper airspace to enter the building. In the process cooler air is drawn into the collector from the building by way of the lower airspace, is itself heated and then discharged back into the building via the upper airspace. This cycle continues as long as there is sufficient solar energy available to make it possible. When the cycle stops, colder, denser air accumulates inside the bottom of the collector and, for as long as the building's interior temperature remains higher than that outside, prevents the re-entry of warm air into the collector and the heat loss that would otherwise occur.

Such collectors must be south-facing, or nearly so, and angled so as to be normal to the midday sun in the middle of the heating season. They are unlikely ever to provide more than, say, 50 per cent of the heating requirement for any particular space and are, in any case, probably only suitable for buildings that are domestic in scale. Even so, they are not without interest but they would have planning implications if they were to be used to any large extent.

Passive solar heating systems with storage
The advantage of systems with a storage capacity is that the heat can be made available when the user requires it

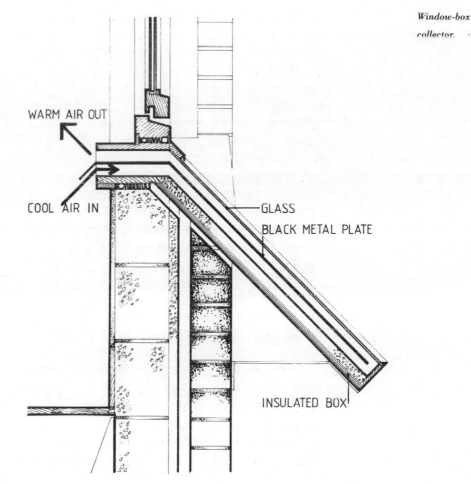

WARM AIR OUT

COOL AIR IN

GLASS
BLACK METAL PLATE

INSULATED BOX

and not only when the system is providing it, as happens with the window-box collector. Heat can be stored in any dense material. The principle is simple: heat the dense material; insulate it so that the heat cannot escape unintentionally; but have a method of releasing that heat on demand. Ideally the dense material should be cheap, readily available, easy to store and have a high thermal capacity. In practice this usually means concrete, masonry or water. The following examples give an outline of the most commonly appropriate systems and indicate how they tend to affect planning. For further information you should consult more specialized texts, although a good, non-technical introduction to the entire subject is to be found in *The Integral Urban House*, edited by the Farallones Institute (San Francisco, 1979).

Direct solar gain
This is the simplest of all storage systems and may be suitable for south-facing spaces (northern hemisphere) where:
1 there is considerable, though by no means total, glazing on the south side;
2 windows are equipped with efficient heat conservation features to prevent heat loss at night;
3 the structure enclosing the space consists largely of materials with high thermal capacity; alternatively, elements within the space may have that quality;
4 north, east and west sides are well insulated.
 Basically, sunlight is simply allowed to enter the space by way of the windows and to fall upon those areas of high thermal capacity, for example, a ceramic tiled

concrete floor slab, or unlined masonry walls. The heat thus stored is gradually released after sunset as the air temperature begins to fall. The space that benefits is usually the one receiving the sunlight, since the stored heat is released mainly by radiation. It is, though, possible to arrive at configurations that permit some of the stored heat to be radiated to spaces other than those facing south. If, for instance, on the north side of a south-facing room there was a masonry wall that could receive the direct rays of the sun, some of the heat it would absorb eventually could be radiated northwards to a space lying beyond.
 Critical to the success of the system are:
1 a ratio of glazing area to area of usable high thermal capacity not less than 1:4 but preferably 1:8, to avoid over-heating during daylight hours due to overload and consequent immediate re-radiation and convection. Note that it must be possible for the sun's rays either to fall directly onto the areas of high thermal capacity or else be reflected efficiently on to them. The more widely the light can be spread across these surfaces the greater their storage capacity;
2 daytime or summer shading devices at or in front of the windows to control excessive solar gain;
3 night-time insulating devices at the windows to prevent thermal loss.
 A slightly more sophisticated version of this system employs roof monitors instead of, or in addition to, windows. The monitors are positioned so as to direct sunlight onto storage walls well inside the building's perimeter, thereby allowing a greater range of plan options. Monitors are affected by the same critical factors as windows.

Top-lit atrium

The top-lit atrium is a rather more elaborate way of
capitalizing on direct solar gain (see above). An area in the
centre of the building acts as a collector, absorbing heat
into its floor and into those walls that face not only south,
but also east and west. Depending on circumstances, the
roof of the atrium can be wholly glazed or else equipped
with monitors that point in different directions. Either
way, heat can be collected throughout the entire day. It is
still necessary, of course, to provide the means of
combatting heat loss at night and to ensure that during the
day there is no risk of overheating.

The Trombe wall

Named after its French inventor, Felix Trombe, the
Trombe wall is, in effect, a large-scale version of the
window-box collector described above. Instead of merely
tacking a collector onto the side of a building, however, the
side of the building itself becomes the collector. Still it
works in a very similar way, by virtue of its special
construction. This consists of a south-facing, massive,
dark-coloured wall (e.g. black-painted concrete or a dark
natural stone) standing some 100mm behind an outer wall
that is entirely glazed. At the top and bottom of the heavy
wall there are ventilation slots through to the interior of
the building. It will be apparent why the Trombe wall can
operate precisely like the window-box collector: air heated
between the stone and the glass rises and enters the
building via the upper slot; meanwhile, cooler air is drawn
out of the building through the lower slot to be heated and
to continue the cycle. Thus, during the day the Trombe

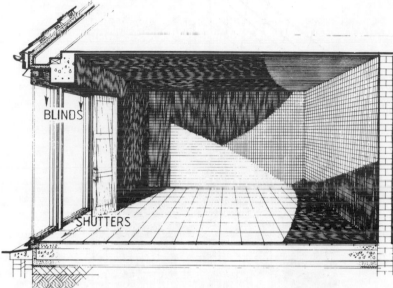

BLINDS

SHUTTERS

*Sectional
perspective on
centre-line of a
south-facing room
at latitude 52°N
designed to
capitalize on
passive solar gain.
Diagram shows
the areas of wall
and ceiling
illuminated by the
sun (either
directly or by first
reflection),
between sunrise
and mid day at
end of March or
September. Ratio
of surface thus
heated to glazed
area is just under
8:1. NB shading
and insulating
devices.*

Orientation,
Daylight and
Heating

95

wall creates what is called a convection loop.

This is only part of the wall's advantage, however: it also capitalizes on direct solar gain, absorbing heat into the masonry or concrete during the day and radiating that heat into the interior during the night. This, in fact, is its primary purpose. Success depends not only on achieving a total mass sufficient to store the amount of heat required, but also on a thickness with a thermal lag (the time taken for the heat to pass through it) that ensures peak radiation internally when it is actually required. As a rough guide, a cubic metre of concrete will store enough heat for three cubic metres of internal space; and the concrete would need to be between 0.2 and 0.3 metres thick to give a thermal lag of 6 to 10 hours.

Further benefits of the Trombe wall are that:
1 it can be load-bearing and, therefore, help support other structural elements such as floors and roofs;
2 the conduction loop can be employed to induce cooling, providing the system is equipped with a suitable series of dampers.

A disadvantage might be reduced opportunities for a southerly view.

Cheaper, non-load-bearing alternatives to the Trombe wall have also been constructed using stacks of metal drums filled with water as a substitute for the concrete or masonry.

The greenhouse
Greenhouses, conservatories and the like can all be used as collectors of solar energy for the purpose of heating adjacent buildings. Air in the greenhouse is heated by the

sun and is then vented by way of doors, windows or ventilators into the building it serves, to be replaced by cooler air from inside the building, the same loop as has been described before. At night, access to the greenhouse is shut off. This is the simplest form and requires careful management. If the greenhouse is also intended to function as such and plants are not to suffer, it may require the means to shade it in summer and to maintain its own night-time temperature during the winter. The latter may be achieved through direct solar gain, making use, perhaps, of a masonry rear wall, a well insulated concrete floor slab or water drums exposed to the sun during the day.

Greenhouses and conservatories can often be added to existing buildings to considerable thermal benefit. More extensive use can be made of them, however, where they are integral parts of completely new buildings. Here the idea of the conduction loop can be exploited to a far greater degree to encompass the entire building, rather than merely those spaces immediately adjacent to the greenhouse. Warm air from the greenhouse can be ducted first to the top of the building, then down the north side, eventually to return to the greenhouse via ducts beneath the floor. Some deliberate sacrifice of warm air may be necessary at the highest point in the circuit in order for the cycle to operate. This can be compensated by small inputs of heat from other sources, for example, direct solar gain, cooking or radiation from surfaces which have themselves been warmed by the air stream.

Systems also exist that couple conservatories with underfloor heating. The air is not used directly but as a means of raising the temperature of a thick bed of stones

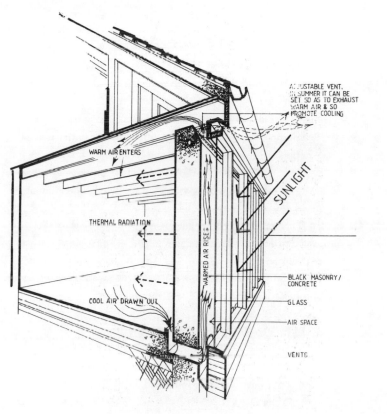

ADJUSTABLE VENT. IN SUMMER IT CAN BE SET SO AS TO EXHAUST WARM AIR & SO PROMOTE COOLING

WARM AIR ENTERS

THERMAL RADIATION

SUNLIGHT

WARMED AIR RISES

BLACK MASONRY / CONCRETE

GLASS

AIR SPACE

COOL AIR DRAWN OUT

VENTS

beneath the ground floor. This 'heat-sink' then slowly radiates into the building through a suitably conductive floor surface.

The use of a greenhouse for the purposes of heating a building clearly has a major impact on the entire plan. It affects not just the siting of the greenhouse but also its area, volume and cross-sectional shape, all of which have to be determined in relationship to the configuration of the building as a whole.

It will be clear that for anything other than the simplest of them, a decision to employ passive, or direct, solar heating systems has profound implications for the planning of the building concerned. Indeed, such a decision has to be part of the initial brief.

Indirect solar heating systems

Since the operation of indirect systems is far less dependent on the actual structure of buildings, even to the extent of being totally independent, their impact on building plans is relatively slight. In their simplest forms they are, in any case, less suited to warming buildings than to warming water for use in the buildings. Typically the collector, which is either similar to the window-box collector described earlier or else is what is termed a flat-plate collector, is in one place (on the roof, for instance) and the heat store (water tank or rock bin) is in another. The medium for transferring heat from collector to store is either air or water via ducts or pipes. Siting the collectors (of which there could be many if the heating requirement is large) to capitalize on the sun's rays might affect the planning. This could also be true of the heat store, if large.

Local radiant heat sources

Local sources of radiant heat are only effective if combined with sensitive local planning. They may also, depending on how the heat is generated, influence planning on a larger scale. Sources requiring the greatest care are open fires, stoves and wall-mounted radiant heaters fuelled by either gas or electricity. The immediate vicinity of the heat source must first be taken into account.

Radiant heat is best at warming bodies, human or otherwise. It flows from its source and heats whatever bodies it encounters: people, dogs, chairs, walls, and so on. It does not, initially, heat the intervening air; not, that is, until the temperature of the various solid bodies adjacent to the source has first been raised. Even then air temperatures may remain lower than would be the case if some other form of heating were used. This does not matter as long as the people for whom the radiant heat source is primarily intended can feel the heat upon them. This is only possible when they are directly in line with the heat source, reasonably close to it and there is
1 no intervening body;
2 no larger, colder body nearby that can be 'seen' by the heat source; radiant heat tends to heat those bodies that are coldest first.

For open fires, stoves and the like to be effective, therefore, they should be located so they are always visible to those they are meant to warm. This is not just because it is comforting to be able to see the source of the warmth but because if the source cannot 'see' you it cannot directly warm you. The following guidelines may be useful in planning the immediate vicinity of the fire or stove:

1 Make sure the heat source can, at all times, 'see' the people it is meant for;

2 Locate doors etc., so that no route passes between the heat source and its intended beneficiaries;

3 Ensure that walls, floors and ceilings 'visible' to the stove or fire are constructed so that either heat is prevented from falling upon cold surfaces or else can themselves warm up quickly;

4 Ensure that the fire can be truly enjoyed for its own sake; fires and stoves serve a deep psychological need in people which should not be ignored;

5 Flues on outside walls are inefficient and prone to condensation and heat loss so put them elsewhere;

6 A stove located in the centre of a space is more efficient than one against a wall as it is able to radiate in all directions.

The effect of open fires and stoves may not be entirely local and this may be intentional. Flues, of course, are always required and have to be encompassed in the planning but, in addition, the positioning of fires or stoves may affect spaces other than those they serve directly. Two examples should help:

1 In certain European countries, such as Austria, large ceramic-clad stoves are positioned at the intersection of four rooms. Thus 25 per cent of the stove appears in each of the spaces and serves them all;

2 Immensely thick and broad, centrally-located brick chimneys found in old Suffolk cottages and elsewhere not only housed the flues from two fireplaces, but also acted as heat stores, gradually releasing heat to all rooms abutting the stack long after the actual fires had been allowed to go out. They also incorporated bread ovens and, on occasion, narrow twisting, brick staircases.

"For open fires, stones and the like to be effective…they should be located so as to be always visible to those they are meant to warm…"

8 Space Provision

How much space is needed? This is not another way of asking: 'How long is a piece of string?'. For the majority of interior design and building projects, it is in fact possible to give positive answers to the question. If a proper brief has been drawn up, targets will have been established, such as: 'the café area must accommodate between 80 and 90 customers at any one time'; or 'there must be three full-size billiards tables with seating for an audience of 300'; or 'the production area has to house 40 operatives, all at model ABC/123 benches, a storage area for up to 80 palettes and a type XYZ/789 flow solder machine'. Using this kind of information, minimum practical floor areas can be easily established either by reference to standard textbooks or by empirical study.

There are authors in most countries who have spent a lot of time collecting, collating and publishing data on specific space requirements. All designers and architects should be familiar with their works and should be in the habit of consulting them whenever practical information is required. There is no need to guess. Note, however, that information published in one country may not be directly applicable in another: national laws, standards and attitudes can all differ markedly. What is therefore deemed appropriate in, say, the U.S.A. may not be suitable for a country in Europe or even in the the U.K.

In order to find out how much space is required for 'between 80 and 90' diners, you consult a reliable source of reference. There you will find the dimensions you require (with variations to allow for different seating and service arrangements). The same is true for billiards tables and the kind of seating that might be used by an audience at a billiards tournament. The production area might be more difficult, since it is not likely to be the kind of place that is often purpose-designed and so may not have made it to the text books. Still, the necessary information can still be pieced together from different sources: dimensions of the specialist equipment should be obtainable from your client or from the manufacturers; space required for a particular

process can be gauged by observation of similar processes or else supplied by the client's production manager; and circulation space in general can be worked out from the standard textbooks.

Once you have the basic data, it needs to be interpreted. Are the figures obtained maxima or minima? Which is the more critical? Are they directly applicable to the job in hand or do they need to be modified in some way? Then, having determined that an area of, say, $1.5m^2$ per diner will be right for your café; or that the billiards arena will require not less than $233m^2$; or that the production area will occupy between 250 and $275m^2$, you can utilize the information as part of your overall planning strategy.

It is, for instance, quite easy to discover how big your building as a whole needs to be. It is simply a matter of looking in turn at each of the activities that the building will house, working out how much space each requires according to your reference source, totalling the resulting areas and then adding on a suitable percentage (guidance may be available from the textbooks) for circulation, structure and anything you might have overlooked. This gives you an overall area that is broadly accurate and can be used as a guide to costs.

Alternatively, if your brief has been less than specific about numbers; or if you are concerned with an existing building and want to discover how many people it could accommodate if, for instance, it were to be converted into a cinema; answers can be found by dividing the per capita figures from reference sources into known overall floor areas. Thus, allowing a minimum of $0.476m^2$ per person

"It is all too easy to kid yourself about what is possible…"

(inclusive of an internal circulation allowance of 27 per cent) an existing floor area of 238m² might be expected to convert to a 500 seat cinema auditorium, at best. More capacious seats, or more space between rows, would reduce the total capacity. Early calculations of this kind can help establish the feasibility of a project. Later on, such calculations can be used to check how efficient your planning actually has been. If the 78m², high-class restaurant you have just designed can only hold 48 diners, but your reference source tells you that at 1.3m² per head it should seat 60, you might conclude that there was room for improvement, unless your client had stipulated that he wanted the place to be unusually spacious.

For students, learning to make use of published spatial information and ergonomic data is an important step. It has to be taken along with two others that are equally important: learning to work to scale at all times (particularly when sketching free-hand plans) and developing an appreciation of the size of things and of the requirements for space generally. It is all too easy to kid yourself about what is possible, particularly if (as can happen at early stages) you are working to a small scale (e.g. 1:100) or, worse, to no scale at all. The precipitous staircases, the microscopic tables and the cars with miraculously small turning circles, all apparently intended for unusually diminutive and agile people, are features that are all too common in first and even second year projects. So, too, are the olympic-size bath tubs and the lavatory cubicles big enough for ballroom dancing classes. Such mistakes testify to a lack of direct observation, fact-finding or both.

Reference has already been made to precisely this need: reference. No one ever designs a building or any part of a building completely from scratch. No two buildings are ever precisely the same; nor is any one building ever totally unlike any other. All have their predecessors, one way or another. Every new restaurant, school or railway station is preceded by thousands of other restaurants, schools and railway stations. Naturally, yours will be different. In reality, however, the differences will not be all that great: an improvement here, a change of attitude there and, of course, the effect of new technology. Yet in many respects your building will resemble earlier buildings of the same kind.

The reason is not hard to find. Buildings are simply cloaks for human activities and much of what we do does not change essentially. This is particularly true of the more practical aspects. Consequently, man has had a lot of time to work out which are the better ways of doing things and to set down his conclusions so that all may benefit. It really is not necessary to re-invent the wheel for every project.

There is, therefore, a wealth of published material to which designers and architects can, and should, refer; not for the purpose of plagiarism, but to profit from other people's experience. If a particularly good way of doing something has been described in the pages of an architectural journal, it would be short-sighted to ignore it. Likewise, if the same journal reports some kind of building failure or design inadequacy, it would be as well to know about it for fear of making the same mistake. Studying the work of other designers and architects; reading the commentaries of critics, journalists, historians

and others; familiarizing yourself with the tremendous wealth of practical information that can be gained from magazines, manufacturers and textbooks; coming to terms with the limitations (often the outcome of bitter experience) of advisory and regulatory documents; all these are part of the necessary reference that underpins any exercise in building design, from the most worthy to the most frivolous.

Earlier chapters have alluded to the fact that most countries have their own national building regulations, codes or standards. In addition to these (or, sometimes, instead of) there may be state, county or city ordinances governing the way buildings are planned and constructed. It is, clearly, important to find out which sets of regulations apply at the very outset of the project. Such regulations usually have the force of law and, consequently, exercise powerful constraints on architects and designers. You thus need to know all about them before you start to avoid sickening discoveries later. Since such laws are inevitably implemented locally, local government offices should be able to point you in the right direction.

Make sure you understand the regulations. Often they are couched in the language of the lawyer and the civil servant, but try not to be put off. You need to know not only what you cannot do but also what you can do, and that frequently depends on being able to spot the gaps between the restrictions. Above all, you need to understand how they may affect the concepts that are fundamental to your design. Not that the restrictions are a bad thing; they simply represent a lot of cumulative experience that might well be helping you to avoid costly or

dangerous mistakes. You have to use them, and not the other way round. After all, who is doing the designing?

In addition to the building laws, there is a whole body of practical planning information that the architect or designer ignores at his peril. There is no excuse for making any space too small, for instance. Handbooks are available in most countries that tell you all you need to know about the minimum size for such things as toilet cubicles, wrapping areas in department stores and ramps for wheelchair users. (I have just opened one such compendium at random.) If you are involved in the design of buildings, handbooks like this are indispensable and should always be close at hand. Beware, though, of cultural differences. What might be regarded as appropriate in the U.S.A. could be out of place in Britain, for instance.

Building regulations and design standards are drawn up to cover buildings of all descriptions. More specific are the design guides, available in some countries, that look only at particular kinds of building or interior. These can be very useful, providing they are used with care. The two worst pitfalls are:

1 the underlying assumptions may not be the same as those for your project;
2 the regulations and standards that they inevitably encompass may be those of some other country and, therefore, may be wholly or partly inapplicable.

At the very least, however, they can alert you to the sort of questions you should be asking (particularly when establishing a brief) even if they do not provide appropriate answers in all cases.

The same is true of case studies and previous examples. Do look at how other architects and designers have tackled similar problems and profit from their experience. But bear in mind that no two briefs are exactly the same. What might look like an eminently employable solution may, in reality, be the answer to a totally different problem. That is the difficulty with criticism: unless you know what the designer in question thought he was trying to do, it is not easy to decide whether or not the solution is a good one.

Never lose sight of the fact, however, that all the fact-finding and all the reference is meant to enable you to solve the problem defined by your brief (Chapter 2).

Escape and the Limitation of Fire

9.1
Introduction

The topic of escape has already been touched upon in Chapter 6. There, inadequate means of escape is identified as one of the hazards that a building itself may present to its occupants or users. Inadequacy in this respect can mean anything from the total absence of proper escape routes to small, but potentially dangerous, design faults in what might otherwise be a perfectly satisfactory arrangement. Therefore, one of the main functions of national and local building regulations is to ensure that every building possesses means of escape appropriate to the building's purpose and to the number of people it is designed to accommodate. Such regulations are legally enforceable, applying to all new work and, more often than not, to renovations and changes of use. Occasionally, new regulations may even be introduced that are immediately applicable to existing buildings whether or not any other work is intended.

Regulations governing the provision of means of escape are frequently both difficult to understand and to implement. But difficulty of implementation usually increases the longer the designer puts off addressing the problem. So, despite the complexity of escape regulations, it is essential to get to grips with them at an early stage of planning; to recognize clearly their implications; and to design accordingly. There is no point at all in getting annoyed with them. They are there to protect people and if a designer's ego is bruised because they appear to prevent his realizing some pet ambition, too bad. In any case, a good designer should be able to take the most vexatious of regulations in his stride and even turn them to advantage.

Unfortunately, escape regulations are by no means standardized. The building codes of different countries or localities can differ considerably. Even within the U.K. there are marked differences between, for example, England and Scotland. Here, not only are requirements expressed differently, the requirements themselves are often different. This is not out of cussedness. It reflects separate and distinctive legal systems together with

differences in social patterns, history, building practice and administrative procedures. Despite this, there is general agreement on the commonest reason for needing to escape, which is fire.

Most of us have never been involved in a fire. Fire is one of those calamities that tend to happen to others. Every time we read reports of deaths due to fire we feel sad, thankful and helpless all at the same time. But we are not helpless. In the buildings we design we can, if so moved, do much to protect the users should fire occur. It should not be necessary to watch, as I have done, desperate people leaping from sky-scrapers to escape flames, to be convinced of the primacy of escape provision and the limitation of fire.

Fire kills. Fire destroys buildings. It should be unthinkable to design a building that is anything other than easy to escape from should fire break out. Ideally, no matter where someone is in a building and no matter what kind of building it is, it should be possible for that person to flee safely in the event of fire. If a blaze breaks out, no one should be trapped; it should always be possible to head away from the fire and to reach safety. Certainly this should be possible while a fire is in its early stages, that is, while it is still concentrated at its source (assuming it has only one). The concept is not a difficult one: no matter where a fire might begin, it should never be necessary to go through it or past it in order to reach safety. The planning this entails is not particularly onerous either, once the necessity is admitted. What is far harder is to provide for escape from fires that have spread or that have more than one source. Consequently, preventing the spread of fire is an additional and equally vital line of defence.

For a building to be ideally safe, therefore, it would need to be designed so that:
1 there were routes by which people could escape no matter where a fire broke out;
2 fire could not spread, particularly where, were it to do so, escape would be cut off.

The first is a matter of planning; the second depends both on architectural configuration and on the careful choice of materials.

Unfortunately, by being so simple and comprehensive this is something of a counsel of perfection – at least where some building codes are concerned. There are codes in some countries that would appear to deny the

danger of fire almost entirely; there are others that, with constant and conscientious amendment, have probably become too complex and too subtle for their own good. Effective fire protection regulations ensure foolproof means of escape to all people in all parts of a building at all times; ensure construction and finishes that prevent the spread of fire; and above all, make both facts manifestly obvious to all those who may have occasion to use a building. Anything other than this is a failure of planning.

To stay within the law, however, the building designer must always know which regulations apply in any particular case. He must check, first, if there are national standards and then look for local ones. In the U.K. the starting point will be one of the following, as appropriate: 'The Building Regulations 1985', which apply in England and Wales; 'The Building Standards (Scotland) Regulations 1981'; or 'The Building Regulations for Northern Ireland (SR 1982 #81)'. These, in turn, are likely to lead you to relevant parts of British Standard BS5588 or CP3; or else to one or another of the many Acts of Parliament concerned with the design of buildings. (There are, for instance, about forty such items of legislation within the U.K. that have a bearing upon fire and its effect on building design.) Since regulations are subject to periodic revision, it is important to ensure that the amendment being consulted is the latest.

If the designer is at all in doubt about the legislation affecting his building, he should check with the building control department of the local administration or with the local fire prevention officer. It is not unusual for different codes, which are not always complementary and sometimes emanating from quite different sources, to be applicable simultaneously. Or, as is currently the case in England, the designer finds that, having bought the costly 'Building Regulations 1985' he is referred by the section titled 'Mandatory rules for means of escape in case of fire' to four other documents instead.

Obviously, the relevant codes have to be understood and implemented. If, as sometimes happens, the codes are mandatory and allow for no deviation, there is little room for manoeuvre. If, however, they represent the minimum acceptable provision then the responsible designer will attempt to do somewhat better. For instance, it is axiomatic that in remote locations there should be safe escape routes from all parts of all buildings intended for human occupancy. Mere conformity with a building code which, perhaps, demands no more than half an hour's fire protection would be of little comfort to those awaiting rescue by a volunteer fire brigade who have a considerable distance to travel. Even in urban areas traffic congestion can make the progress of fire engines frighteningly slow. Above all, the designer should have constant regard to first principles: to plan buildings in such a way that in the event of fire, it is hard for it to spread and easy for people to get out. The remainder of this chapter concerns itself with first principles. It looks at fire and at its implications for the planning of buildings.

"...There should
be safe escape
routes from all
parts of all
buildings..."

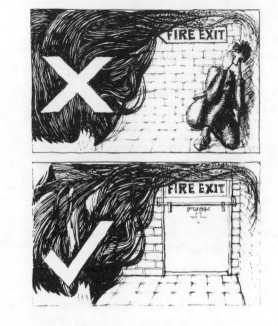

For fire to occur, three factors must coincide:

1 there must be material that will burn;
2 there must be sufficient heat;
3 there must be sufficient oxygen.

If any of these is wholly missing, there can be no fire. If all three are present, but to a limited degree only, there may be smouldering; this, eventually, may become fire. However, by starving it of one or more of these three factors – fuel, heat and oxygen – a fire can be extinguished. For example, potentially combustible material may be removed; or foam applied to cut off the supply of air; or, where safe to do so, the temperature reduced by the application of water.

Fire produces:

1 heat;
2 smoke;
3 gases;
4 flame;
5 light.

In the context of a building fire, the first four are always extremely dangerous; even the fifth may pose problems on occasion.

Heat

Fire requires heat to start. Once started, providing an adequate supply of combustible material and oxygen remain, fire generates further heat thereby facilitating its own spread to parts hitherto unaffected.

Smoke

Smoke is usually present from the very start of a fire. It is

the result of incomplete combustion and consists of minute particles released as a result of the chemical breakdown that fire brings about in a material. Not only may the particles themselves be hot, thereby contributing to the spread of heat, but they are also irritating (to the eyes and to the respiratory system) and frequently highly toxic. Some particles may themselves become combustible, thereby raising the temperature even further. Smoke can, and often does, kill. Death is more often due to asphyxia or poisoning resulting from smoke inhalation than to being consumed by fire. Nor is inhalation of smoke the only hazard: smoke can blind, obscure, disorientate and mislead.

Gases

Gases are constituent parts of smoke. They may be poisonous (see above) and they may be volatile, that is, they may burst into flame. This is known as a flash-over. It is, literally, an explosive situation. Windows and doors may be blown out, thereby allowing an inrush of air that further fuels the fire. People caught in the blast may be maimed or killed.

Flame

Flame may be defined as 'the zone of oxidation of gas, usually characterized by the emission of heat and light'. In other words, flame is a combination of air and gases which, in most circumstances, gives off heat and light. It does this within a spatial volume which may or may not be constant, depending on the sources of the air and the gases. (This may help you see how spontaneous combustion occurs:

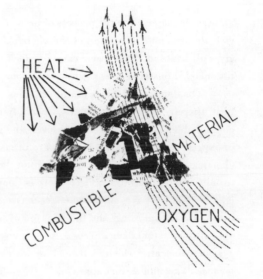

"For fire to occur, three factors must coincide…"

an organic material, in the process of natural decay, may give off gases and, as a result of this chemical change, it gives off heat too. Thus it generates for itself two of the factors needed to start a fire; a gentle breeze may do the rest.)

The danger of flame is that it provides a source of heat, thereby raising the temperature of adjacent combustible material. At a certain level, and given a supply of oxygen, the material will also start to break down chemically, bringing about its own ignition. Ignition is usually a two-phase affair. First, there is smouldering, that is, a form of partial combustion characterized by incandescence (glowing) and the emission of smoke but, as yet, without actual flame. Second, as heat rises further, gases are liberated which then combine with air. The result is more flame and the fire spreads.

Light
Light is not usually a hazard of fire but there are occasions when it can be. Very high temperature fires involving aluminium or manganese, for example, can give off a light that is blinding. Flash-overs have sometimes been described by survivors as 'blinding', too; although being blown over is the commonest hazard here.

How fire spreads in buildings
As we have seen, the four stages in the growth of a fire are normally:

1 smouldering;
2 smoke;
3 incandescence;
4 flame.

Given the necessary level of heat, availability of combustible fuel and an adequate air supply, a fire advances in waves through a building, unless prevented from doing so. Once initiated, the heat from the fire itself causes smouldering (i.e. combustion without flame) in adjacent combustible materials which themselves burst into flame when they reach their individual ignition points (between about 250°C and 400°C depending on the material). Smouldering releases smoke containing a whole range of toxic substances some of which, like carbon monoxide, can be lethal even at quite low temperatures (80° to 100°C). As smouldering reaches a high temperature, the fuel is liable to glow and may ignite any volatile gases already released. This is called flash-over and the spread of flame can be extremely fast as it races across surfaces that have already become heated. Another form of flash-over, usually termed smoke explosion, occurs where a low-temperature smouldering fire has released volatile gases as a relatively small percentage of the smoke generated. If the fire continues to glow, however, and if air is suddenly introduced, (when, for instance, someone opens the door to find out where the smell of burning is coming from) an explosive flash-over can occur.

The likely result of such an explosion (increasing air pressure by up to $10kN/m^2$) is that windows and doors are blown out. At this stage the fire has unlimited oxygen and can advance more quickly. Not that a smoke explosion is needed to blow out windows: the heat of the fire inside a building can itself push up air pressure to a degree where windows give way. Then flame, or smoke bursting into flame, can spread up the outside face of the building

causing windows at higher levels to break. In the turbulent pattern of air movement, the flame is then sucked into the floors above.

Before reaching the outside walls, however, the fire will have travelled horizontally. In buildings having more than about three stories this is the commonest way for fire to spread. Most buildings of this kind tend to consist of more or less separate horizontal layers, with vertical circulation contained within vertical shafts designed to be proof against fire. As a result, fire tends to advance horizontally via corridors, ceiling voids and larger spaces generally, until reaching the perimeter. There, it can spread to the external face of the building before re-entering at the next and subsequent levels. In spreading fire horizontally, corridors and ceiling voids can act like flues. Either differential pressure at opposite ends of the horizontal space draws the smoke through or, volatile gases having accumulated in the ceiling, flash-over or smoke explosion can occur.

One way or another the horizontal spread of fire can be very rapid; quicker, sometimes, than a man can run. It is for this reason that long corridors are often equipped with fire check doors, not only at their ends but also at intermediate points, in an effort to slow the pace of any advancing fire. Unfortunately, building users have a habit of propping such doors open to facilitate their everyday business. Even when such doors are properly closed, the build-up of atmospheric pressure on one side, due to fire, will force smoke under them or through any other crack or aperture, thus insinuating the danger from one space to another.

In buildings where there are open vertical shafts – staircases, light wells, covered internal courts (atria) and the like – there is an easy route for fire to reach upper levels. As we have seen smoke is not only a sign that there is fire, it is very often the means by which fire spreads. Smoke's initial tendency is to rise and so internal wells act as enormous chimneys. It is essential that the cross-section of any such space does not allow smoke to be trapped at any upper levels opening directly on to it. In the case of the corridor ceiling, once smoke can rise no higher it begins to move rapidly sideways until it can go no further and then to fill downwards to engulf the floor.

To recapitulate, therefore, the building designer has two planning tasks to confront:
1 to make it possible for people to escape;
2 to arrive at a three-dimensional configuration, both in general and in detail, that inhibits the spread of smoke and flame.

(Allied to these, of course, materials and finishes have to be chosen whose characteristics do nothing to assist combustibility or flame spread. These questions are considered elsewhere.)

What follows is an analysis of potential escape problems and how, as far as planning is concerned, they can be countered. The analysis is based on 'The Building Regulations, 1985' (which are applicable in England and Wales) and 'The Building Standards (Scotland) Regulations 1981' but it should not be read as a definitive interpretation of either. The purpose is merely to indicate the kind of problems which have arisen in the past and to show how, in the United Kingdom at least, building law is now framed to protect people in the event of fire breaking out. Remember, though, we are only concerned here with questions of planning. Other aspects of building which may have a bearing on escape (such as fire protection, fire resistance and structural fire precautions) are dealt with elsewhere.

Planning for escape depends on one central idea: this is the escape route. The meaning of this term is quite specific. It is applied only to certain designated routes that are meant specifically to lead to safety. The provision of such routes is a fundamental consideration when planning any building for three reasons. First, their length has to be limited if they are to be of practical benefit, thereby having a profound effect on building shape and planning generally. Second, they occupy volume which cannot, for the most part, safely be used for anything else. Third, they exert certain constructional constraints.

Broadly, an escape route may be defined as a particular route, leading from any given point inside a building, by which a person may reach somewhere safe. Thus, no matter where you are inside a building there should be one or more safe routes by which you can escape in the event of fire. It is important to remember, however, that an escape route is not just any route. For instance, it is quite possible that from some parts of a building, there may be many possible ways out; but only those ways that have been specifically designed to be safe are actually escape routes. Those routes only will have been designed to afford some measure of protection to users should fire break out. Only these routes are likely to be safe.

Escape routes are different from other routes, therefore. Their position, length, configuration (i.e. shape allied to the design of its parts and their details) and mode of construction are all determined solely with a view to safety. U.K. building regulations lay down strict requirements for all four of these determining factors. What makes the regulations difficult to implement, however, is that the factors vary: first, because they depend upon the nature of the building, its size and the number of people using it; and second, because they are interdependent. As a result, it is not possible to state a universal rule of thumb for the provision of escape routes for buildings of every description. The architect or interior designer must always familiarize himself with the regulations that apply both nationally and locally and then work out their implications for his particular building.

Minimum number of escape routes
The first question to be asked is whether or not the regulations lay down a minimum number of escape routes for the kind of building you are designing. This will depend on three factors:

1 the building's use or purpose;

2 the number of floors in the building and their height above (or below) ground level;

3 the number of people each floor is intended to accommodate.

For example, in a Scottish hotel, where a storey can accommodate not more than 25 guests and that storey is not more than 11 metres above ground level, it may be permissible to have only one escape route. Storeys with the same capacity, however, but higher up the building might need two. If instead of being a hotel, that same building were to become a school boarding house, even though it continued to house 25 people (i.e. children) per floor, every floor might require two escape routes, no matter how close to the ground.

It may be surprising that any regulations should permit any circumstance where there is only one escape route. Common sense would seem to dictate that no matter where anyone is in a building there should always be at least two possible ways of getting out safely in the event of fire. Thus, if a fire were to start at the very entrance to one escape route, it ought to be possible for people to reach another. The arguments against this rest on two points: the desire to economize, and the fact that fire might be thought unlikely to originate in certain parts of certain buildings. In some circumstances two or more escape routes would be thought too costly and too demanding on the space available. Additionally, in some parts of a building the chances of a fire breaking out might be thought so negligible as to warrant only one escape route. So, parts of some buildings have no alternative escape routes. Instead they are built to offer protection from fire for a minimum

period of time required by the governing regulations. In theory this allows rescuers time to reach anyone who might be trapped inside. Frankly, I would rather be given a better than evens chance to get out.

What exactly is an escape route?

An escape route is the entire route that must be taken in order to reach a place of safety, no matter where the route starts. (A place of safety can be defined as an outside area at ground level from which people can freely disperse at all times.) At ground floor level that may mean no more than crossing the room, opening a door and stepping outside. Where such direct access to a place of safety is not possible, the escape route must first lead into an area that offers some protection from fire; this, in its turn, must lead straight to a place of safety. Areas such as these, variously known as protected areas or protected zones, must always be wholly enclosed and quite distinct from the other parts of the building they serve.

The siting of protected areas is critical. In the first place, limits are imposed on the maximum distance anyone would have to travel before gaining access to a protected zone. In the second place, protected zones must be located to provide genuinely alternative means of escape.

Entry to such protected areas or zones is always by way of protected doorways, that is, doorways designed to resist fire for a specified period of time by virtue of their construction, their detailing and the fact that they are self-closing. A protected doorway may be further protected by a protected lobby – a lobby that is within the protected zone and yet separated from it by a second self-closing fire

Escape routes – 1

The underlying concept: *an escape route is a route to be taken from any given point in a building in order to escape safely.*

This would be ideal:

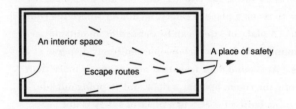

Direct access from an interior space to a place of safety (i.e. outside). Generally this is only possible in certain single storey buildings.

A more typical arrangement:

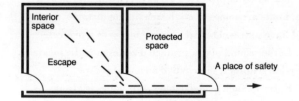

Where direct access to a place of safety is not possible, escape is via a protected zone/area.

Escape routes – 2

Protected zones/areas are constructed so as to be protected from fire (for a limited time-span). In buildings where it is not possible to escape direct to a place of safety (because of the building's size or configuration) escape routes must always be via protected zones/areas.

A protected zone/area is entirely enclosed within fire-resistant construction. The spatial volume it contains must not 'flow' into any other space not similarly enclosed. Access from a building to its protected zone(s)/area(s) is always by way of protected doorways.

Protected doorways and their doors are constructed so as to be protected from fire for the same period of time as the zones/areas they serve.

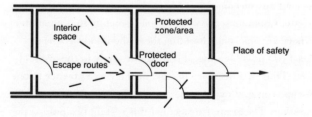

Protected doors are self-closing and must not be left open.

Escape routes – 3

Protected zones/areas may serve more than one interior space ...

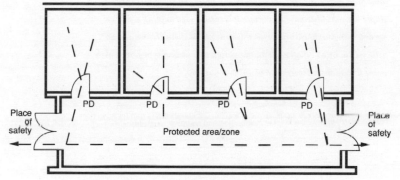

... *and may lead to more than one point of safety.*

Protected zones/areas may be

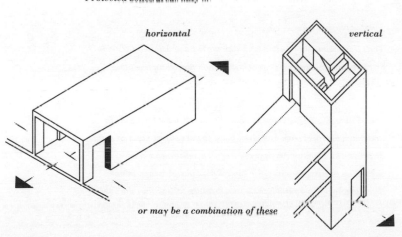

horizontal vertical

or may be a combination of these

Escape routes – 4

Protected zones/areas may be further protected by the inclusion of protected lobbies. In this way entry to a protected zone/area is via not one protected door, but two, with a space, or lobby, between. This protected lobby is part of the protected zone/area.

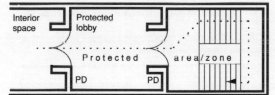

Protected lobbies are particularly necessary where two or more unprotected areas converge at a protected door – i.e. at a point of entry to a protected zone/area.

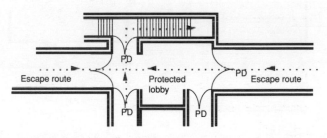

Protected lobbies *not only provide an additional line of defence against the spread of fire into the protected zones/areas themselves; but also permit them, in some circumstances, to be (a) fewer in number, (b) more widely dispersed, or (c) in the case of passageways and staircases, narrower. The underlying assumption is that, in the event of fire, more escape routes are likely to remain available for use where there are protected lobbies than there would be otherwise*

Direction of escape. *In an ideal building there would be nowhere from which it was not possible to escape in at least two different directions (i.e. diverging by at least 45°) – so if one intended route was blocked by fire, there would always be an alternative. This is in fact a legal requirement for parts of many buildings.*

Direction of escape. *There are exceptions to the requirement for a minimum of two escape routes from any point. In some instances a single escape route may be permissible initially, providing a choice becomes available within a short distance (this distance may be as little as 1m or as much as 18m, according to building type), at which point a minimum divergence of 45° is required.*

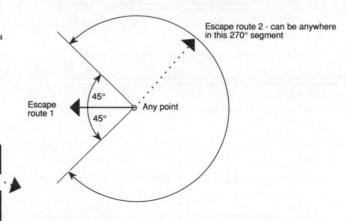

Thus it is sometimes possible for buildings to have dead-end corridors or rooms which can only be reached via not more than one other room.

Travel distance *defines the maximum distance it would actually be necessary to travel from any given point to the nearest place of safety or protected doorway (as appropriate). This distance varies according to circumstances: 9 – 45m. Where initial escape in one direction only is permitted, the initial distance falls within the overall travel distance.*

resistant door. Protected zones themselves must resist fire (for between one and four hours, generally, depending on the building's use) and be wholly, or largely, constructed in non-combustible materials.

Escape routes from upper floors and basements, therefore, are always protected zones. This is also true at ground floor level where there is no direct access to a place of safety.

Protected zones invariably consist of the following: corridors, lobbies and staircases. Of course, not all corridors, lobbies or staircases constitute, or are part of, protected zones; nor are they necessarily parts of escape routes. The only other provision occasionally made within a protected zone include lavatories, reception or inquiry areas and cupboards that are themselves fire-protected.

Since an escape route must be designed and detailed to make escape as safe as possible, it must not contain lifts, escalators, revolving doors or turnstiles. Staircases must meet certain general requirements concerning size and pitch. They must also meet particular requirements concerning width relative to the number of people to be served. The latter is also true of all parts of an escape route.

Escape routes serving any one point are usually required to be completely separate from one another. Thus, if a room is required to have two escape routes, each is by way of its own protected door and then continues on its own totally separate way until it reaches a place of safety. This, ideally, should be different for each route. There are, however, limited circumstances where it may

be permissible for a room first to give on to one other room or non-protected passage and then for this to lead directly to the required separate escape routes via protected doors (i.e. those that are self-closing and fire resisting). The limitations governing such an arrangement are intricate and vary considerably from country to country. Broadly, however, they tend to entail: relatively low occupancy factors (see below); short travel distances; an assessment of the fire risk in the intermediate space relative to the space it serves; both spaces being in the control of the same people; stipulations regarding the way the two spaces are divided; and the provision of fire detection and alarm systems. As always, it is essential to find out what the precise limitations are in the codes appropriate to your building.

How many escape routes should there be?

For any building there will be an infinite number of escape routes. Remember, an escape route is a route to safety from any point inside. No matter where someone might be inside a building there has to be one or more escape routes from that point. This sounds impossible but it is not, simply because large numbers of such routes converge after a pace or two and then head for the same protected area. Therefore, the actual number of escape routes is determined in two stages. First in respect of each separate area and then in respect of each storey.

The number of escape routes from a given area will depend principally on the number of people it can accommodate. It may also be affected by its relative proximity to a protected area. In areas not designed for

specified numbers of occupants – where, for instance, seating is not fixed – formulae exist for arriving at what is usually termed the occupancy factor, that is, the notional capacity. Different building codes have different formulae.

The number of escape routes from a storey will depend on five factors: the use or uses to which the building is put; the level of the storey above the ground floor storey, expressed either as an ordinal (third, fourth, fifth, etc.) or as a vertical distance; the occupancy factor of the storey as a whole; the size of the building on plan; and the shape of that plan. In buildings of more than one storey, the number of escape routes from any upper storey is effectively the same as the number of protected stairways serving it. The same is true for any basement. No such convenient generalization can be made in respect of single-storey buildings, however.

How far can it be to a protected zone?
There are up to five points to be considered:
1 Is it the only protected zone?
2 What is the relationship on plan between the protected zones, where there is more than one?
3 What is the purpose of the building, or that part of it, served by the protected zone(s)?
4 Do the building's users belong to a group for whom special provision must be made?
5 Does the building's form or construction belong to a type to which special limitations apply?

The following sections take these points in order and discuss them fully.

Number of protected zones
Places served by a single protected zone offer less security than those with two or more. Consequently, permissible travel distances (the maximum actual distance anyone would have to travel in order to reach the safety of the protected door that gives access to the protected zone) are considerably less. Typical examples are 15m in a Scottish television studio, or 18m in an English office block. If, however, each had at least two protected escape routes, the maximum travel distances would be 32m and 45m, respectively.

It is not simply enough to provide two or more protected zones in order to achieve greater permissible travel distances. There are other criteria that also have to be met. These concern the positions of the protected zones and the nature of the construction that separates them. Thus, an area that is apparently served by two protected zones may be regarded as having only one; this would be the case if the space lying between them is not itself enclosed by construction possessing a certain minimum fire resistance.

Relative positions of protected zones
It is, in fact, the relative positioning of the protected zones that is most critical at the planning stage. It is vital that they really do offer alternative directions to people trying to escape. Ideally, that would mean always being able to choose one of at least two escape routes and that those two routes would lead in completely opposite directions, that is they would diverge at an angle of 180°. It is recognized, however, that this is frequently impossible to achieve in

practice: that the complexities of planning buildings do not allow such an ideal choice to be available in all parts. Therefore, it is generally agreed that an angle of 45° should be considered an acceptable minimum angle of divergence. This means that from any point in a building where a choice of escape routes is possible, the angle between those routes should be not less than 45°. Thus, lines drawn on plan from any point within the space immediately prior to the protected doorways to any two of these doorways must diverge by not less than 45°. If they do not, it will be as if there is only one protected zone.

Not all spaces, however, are immediately prior or adjacent to a protected zone. The need in almost any building to enclose and to separate one activity from another gives rise to spaces that have only indirect access to protected zones. From many such places, even though it may be possible to reach two or more protected zones eventually, there will no initial choice of escape route. For instance, it may be necessary to cross a room to its only door before emerging into a corridor that then offers a choice of turning left or right, reaching a protected zone either way. Or it may be necessary to cross an inner room to its only door, cross an outer room and only then emerge into the corridor. Similarly, in an auditorium or lecture hall there will be only one initial escape route from a seat at the end of a row, next to the wall, until reaching the aisle where it should be possible to go either up or down. In cases like these, strict limitations are placed on the distance which may be travelled and, on the number of intervening spaces, if any, which may be traversed before a choice of routes occurs.

Depending upon the type of building, the country and upon the ultimate angle of divergence, that distance may be as little as 1m or as much as 18m. As for intervening spaces, their number should never exceed one. Even then, limitations may apply: the risk factor in the outer room clearly should not exceed that in the inner room; the two rooms may have to be connected in such a way as to permit anyone in the inner room to detect an outbreak of fire in the outer room immediately; and both inner and outer rooms may have to be used by the same people. As always, it is vital to familiarize yourself with the appropriate building codes to discover what is applicable in any given case.

9.5
A Building's
Purpose as a
Guide to
Travel
Distances

A building's purpose determines permissible travel distances. The greater the risk, the shorter the travel distance. Risk may be thought to depend not only on what the building is used for, but also on the number of people using it; the latter has no effect on travel distance, only on the number and width of escape routes. Classifying buildings or areas by risk results in three groups:

Lower risk

1 office premises of all kinds;
2 industrial premises of all kinds;
3 places for the storage of non-hazardous materials, garaging, etc.

Higher risk

1 residential accommodation of a communal kind, such as clubs, boarding houses, monasteries, hotels, children's homes, old people's homes, hospitals, etc.;
2 certain types of commercial premises, including shops and laboratories;
3 assembly spaces, such as stations, sports stadia, pavilions, gymnasia, sports clubs, swimming pools, schools, colleges, clinics, surgeries, churches, courts of law, museums, art galleries, public libraries, public houses, theatres, cinemas, public halls, restaurants, cafés, canteens, etc.;
4 places for the storage of hazardous materials.

Special risk
Any building or part thereof designated by the appropriate building code as posing special fire risk. This most commonly refers to plant rooms where heat in excess of

44Kw is generated (depending on method). Special provisions are often laid down for such areas requiring, for instance, dedicated escape routes.

Basically, ignoring any modifying factors that might apply, the maximum travel distances for the three groups are as follows:

Lower risk	Single escape route	18m total
	2 or more escape routes	45m total
Higher risk	Single escape route	15m total
	2 or more escape routes	32m total
Special risk	Single escape route	9m *
	2 or more escape routes	18m *

Measured to door(s) of room. Total travel distance to be as for building type.

If, ultimately, it is possible to escape from a point in a building by two or more routes, it is permissible for there to be only one possible direction of travel initially. In other words, it is alright for there to be only one escape route at first, provided that, after a certain distance, a choice becomes possible. Thus, where escape is initially possible in one direction only but subsequently in two directions or more, the maximum permissible travel distances for escape routes are:

Lower risk	first part (no choice)	18m
	overall	45m
Higher risk	first part (no choice)	15m
	overall	32m

Two examples should clarify this.

In a school it may be permissible to travel as much as 15m from one end of a large art room to its only door at the other end. From that doorway, however, there has to be a choice of routes leading to protected zones which should not be more than another 17m away. In an office building, however, the maximum travel distance within the typing pool to a single door would be 18m and any appropriate protected zone would have to be within a further 27m. The total travel distances are 32m and 45m respectively.

Note that when measuring travel distance, it is assumed to be the shortest possible route to a protected doorway for someone travelling in a normal manner. Thus, it is measured around all obstacles, fixtures, items of fitted furniture, etc. If the route encompasses a staircase, it is measured up its pitch line (i.e. a notional, sloping line up the centre of the stair, connecting all its nosings). In the case of buildings that are put up speculatively and where, therefore, protected zones must be located without any detailed knowledge of how the interior space might be later subdivided, some building codes allow the concept of 'direct distance', being the shortest distance, as the crow flies, from any given point to a protected doorway. Maximum direct distances are generally two thirds of the maximum travel distances that would otherwise apply.

In buildings that are designed specifically for people who are either disabled or elderly, permitted travel distances are reduced. Clearly, it is more difficult to evacuate a building that is largely occupied by those who for one reason or another are relatively immobile. The speed with which they move, or can be moved, is less than normal. To compensate, protected zones are both more numerous and less widely separated than would be the case in comparable buildings designed for the able-bodied. Note, however, that we are talking only about those places specifically meant for use mainly by either the disabled or the elderly. Reduced travel distances do not apply where they are not the main occupants or the occupants for whom the building was principally intended, although such people may have access. It is argued that in the case of council offices, for instance, where several wheelchair users are employed there is a far greater proportion of able people to help them escape in the event of fire than would be the case in an old people's home. Thus, although the council offices would have ramps to allow easy wheelchair access and a suitable provision of lifts, travel distances would be the same as for any other office building. Yet in old people's homes, schools for the blind, rehabilitation centres for paraplegics and similar places, maximum permitted travel distances are:

escape in one direction only	9m
escape in two or more directions	18m

It has already been stated that lifts should not be considered as part of an escape route and that they should not be located within protected zones. Lifts, so useful in normal circumstances, become extremely hazardous in the

9.6
Special
Provision
for Certain
Categories
of User

event of fire. Not only is the lift shaft a potential flue, the operation of the lift itself is uncertain and the car is liable to overloading. In British office buildings, for instance, British Standard BS5810 requires that areas for both employees and the public should be accessible to wheelchair users. If, then, fire breaks out in an office building where lifts form a necessary part of the internal circulation, what should anyone in a wheelchair do? If their presence and whereabouts are known, it should be possible to get them to a protected zone and then to carry them down any stairs. However, if for any reason this is not possible, BS5588 (Part 3), 1983, states: 'It will be necessary for ad hoc arrangements to be made…in the event of evacuation'. It also says that lifts may have to be used, 'provided that appropriate management arrangements can be made'. One is entitled to doubt whether such arrangements would be likely to prove entirely satisfactory.

One way to limit the spread of smoke and flame within a building is to subdivide it into separate parts. A building that consists of smaller separate volumes resists the spread of fire better than one which does not, providing that the walls and floors that create the subdivisions are themselves resistant to fire and that there are no permanent gaps that would allow smoke to move from one space to another. Clearly, in a building that comprises, say, just one large internal volume there are no parts of the building itself to act as barriers to the spread of fire. Yet in buildings consisting of numerous separate smaller volumes, the separating elements, if properly designed and constructed, can delay or even prevent fire spreading.

Some activities require large volumes of space. Even so, building codes often insist that volumes should not exceed a certain cubic capacity or that floor areas be limited in some way. Thus, very large buildings are frequently split into what are termed compartments, to provide some structural precaution against fire. This is done by means of compartment walls and compartment floors, the elements of structure designed to resist fire for a minimum specified period of time. This is never less than half an hour and may be as much as four hours. As for tall buildings, many (though not all) will necessitate division horizontally, irrespective of the size or number of the volumes they contain and even though actual floor areas may be quite small. Regulations can insist that compartment floors are inserted at specified maximum intervals above ground level.

Just as large or tall buildings will have to be compartmentalized, buildings that are divided between

9.7
**Effect of
Form and
Construction
on Provision
of Protected
Zones**

different owners or different types of activity must be separated. In other words, separating walls or floors, having similar attributes to compartment walls and floors, separate one part from another.

A picture should now have emerged of large, tall or differently occupied buildings which have inside them certain walls and floors (though by no means all) that are built to offer structural resistance to the spread of fire. The position of such walls and floors in relation to protected zones is clearly important. There can even be situations where each compartment or each separated area or volume has to be treated individually.

The following tables, which are simplified versions of those appearing in the regulations governing building construction (a) in England and Wales, and (b) in Scotland, may be used as a guide to the following:
1 maximum permissible cubic capacities for particular types of building or for compartments therein;
2 maximum permissible floor areas for each storey in particular types of building; or, where the building is compartmentalized, for every storey of each compartment;
3 the minimum period of resistance to fire for specified parts of the building or compartment; broadly, this means the elements that support, enclose, divide or separate.

It will be seen that the figures are not only interdependent but that they further depend on one, or both, of two other figures. These are:
4 the number of storeys possessed by a building;
5 the building's height or that of its compartments, if any.

Other possible modifying factors, such as the position of buildings relative to the boundary or the presence of sprinkler systems, have for the most part been ignored to permit a general picture to emerge. The building codes themselves should always be consulted for precise detail.

While both tables cover the same ground, their figures are by no means the same. This provides a good example of the extent to which building codes can differ, even within the member countries of a union.

	Building or separated part maxima:		Building or compartment maxima:		Minimum period of resistance to fire (hours)
	floors above ground (no.)	height (m)	capacity (m³)	area (m²)	

Houses

floors above ground (no.)	height (m)	capacity (m³)	area (m²)	resistance to fire (hours)
1	–	–	–	$\frac{1}{2}$*
<4	–	–	–	$\frac{1}{2}$*
4	–	–	250	1†
other	–	–	–	1*

Flats/Maisonettes and other residential

1	–	–	3000‡	$\frac{1}{2}$*
3	–	–	500‡	$\frac{1}{2}$*
<3	–	–	250‡	1†
>3	28	8500§	3000	1*
>3	–	5500§	2000	1$\frac{1}{2}$*,†

Institutional

1	–	–	3000‡	$\frac{1}{2}$*
other	28	–	2000‡	1*
other	>28	–	2000‡	1$\frac{1}{2}$*

Assembly

1	–	–	3000	$\frac{1}{2}$*
1	–	–	–	1
>1	7.5	–	500	$\frac{1}{2}$*
>1	15	3500	–	1†
>1	28	7000	1000	1*
>1	>28	7000	–	1$\frac{1}{2}$*

Offices

1	–	–	3000	$\frac{1}{2}$*
1	–	–	–	1
>1	7.5	–	500	$\frac{1}{2}$*
>1	15	3500	–	1†
>1	28	14000	5000	1*
>1	–	7000	–	1$\frac{1}{2}$*

Shops

1	–	–	2000	$\frac{1}{2}$*
1	–	–	3000	1
1	–	–	–	2
>1	7.5	–	500	$\frac{1}{2}$*
>1	15	3500	–	1†
>1	28	7000	1000	1¶
>1	–	7000††	2000††	2§§

Industrial

floors above ground (no.)	height (m)	capacity (m³)	area (m²)	resistance to fire (hours)
1	–	–	2000	$\frac{1}{2}$*
1	–	–	3000	1
1	–	–	–	2
>1	7.5	–	250	$\frac{1}{2}$*
>1	7.5	1700	–	$\frac{1}{2}$*
>1	15	4250	–	1†
>1	28	8500	–	1¶
>1	28	28000	–	2§§
>1	>28	5500	2000	2§§

Other non-residential (=storage)

1	–	–	500	$\frac{1}{2}$*
1	–	–	1000	1
1	–	–	3000	2
1	–	–	–	4
>1	7.5	–	300	$\frac{1}{2}$*
>1	15	1700	–	1†
>1	15	3500	–	1¶
>1	28	7000	–	2§§
>1	28	21000	–	4
>1	>28	–	1000	4

Notes:

< less than.

> greater than.

– no limit specified.

* + $\frac{1}{2}$ hour for certain elements; also for basements, where these exist.

† – $\frac{1}{2}$ hour for certain elements.

‡ limit per storey.

§ limit per building.

¶ + 1 hour for basements.

†† can be doubled where there is a sprinkler system.

§§ + 2 hours for basements.

Cat.	storeys (no.)	height (metres)	capacity (m³)	area (m²)	Minimum period of fire resistance (hours)
A1	<3	–	–	230	1*
A2	1/>1	15	–	460	1*
	1/>1	24	–	460	1
	1/>1	–	–	460	1½
A3	1/>1	9	4200	1900	1*
	1/>1	24	8500	1900	1
	1/>1	–	14000	1900	1½
A4	1/>1	9	2800	1400	1*
	1/>1	24	5700	1400	1
	1/>1	–	8500	1400	1½
B1	1/>1	6	1130	4600	1†
	1/>1	12	4200	4600	1*
	1/>1	24	14000	4600	1
	1/>1	–	28000	4600	1½
B2	1/>1	6	708	2800	1*
	1/>1	12	2120	2800	1½*
	1/>1	24	4200	2800	2
	1/>1	–	7100	2800	3
	1/>1	–	14200	3700	3‡
C1	1/>1	–	–	–	½§
C2	1/>1	7.5	4200	1900	1†
	1/>1	18	8500	1900	1*
	1/>1	30	14000	1900	1
	1/>1	–	21000	1900	1½
C3	1/>1	6	566	1900	1†
	1/>1	12	2800	1900	1*
	1/>1	24	14000	1900	1
	1/>1	–	–	1900	2
D1	1	–	–	9000	½§
	1	–	–	93000	1
	1/>1	9	8500	7400	½¶
	1/>1	15	28000	7400	½§
	1/>1	–	84000	7400	1

Cat.	storeys (no.)	height (metres)	capacity (m³)	area (m²)	fire resistance (hours)
D2	1	–	–	1400	1*
	1	–	–	7000	1
	1	–	–	33000	1½
	1/>1	9	1700	2800	1†
	1/>1	12	4200	2800	1*
	1/>1	15	8500	2800	1
	1/>1	24	17000	2800	1½
	1/>1	–	28000	2800	2
D3	1	–	–	460	1*
	1	–	–	900	1½*
	1	–	–	2300	1½
	1	–	–	9000	2
	1/>1	9	708	900	1*
	1/>1	12	1410	900	1½*
	1/>1	15	2800	900	1½
	1/>1	24	4200	900	2
	1/>1	–	8500	900	3
E1	1	–	–	900	1*
	1	–	–	2300	1
	1	–	–	14000	2
	1/>1	9	815	2800	1†
	1/>1	12	1410	2800	1*
	1/>1	15	2800	2800	1
	1/>1	24	8500	2800	2
	1/>1	–	21000	2800	3
E2	1	–	–	90	1½‖
	1	–	–	190	1½*
	1	–	–	280	2*
	1	–	–	460	3
	1	–	–	1000	4
	[1	–	–	2000	4§§]
	1/>1	9	425	460	1½††
	1/>1	12	850	460	1½*
	1/>1	15	1410	460	2
	1/>1	24	2120	460	3
	1/>1	–	4200	460	4

Notes

Cat. category of building use as classified by occupancy.

< less than.

> greater than.

– no limit specified.

Depending upon the occupancy group of the building; whether or not it is compartmented; the nature of the element (e.g. floor, structural frame, wall, etc.); and the nature of the construction and/or its position: the following notes may apply as indicated above.

* *$^1/_2$ hour less for some elements.*

† *may be nil for some elements.*

‡ *applicable to certain shop premises only.*

§ *may be $^1/_2$ hour more for some elements.*

¶ *may be $^1/_2$ hour less for some elements and $^1/_2$ hour more for others.*

†† *may be 1 hour less for some elements.*

§§ *applicable only to bonded warehouses equipped with sprinkler systems.*

For any specific area, the answer depends on four factors:

1 how many people the area is intended to accommodate;

2 how many escape routes it will have;

3 whether access to protected zones is by way of protected lobbies;

4 whether all routes are required to be of equal width.

Each of these four factors will be looked at in turn.

How many people does a space hold?

Sometimes this is quite obvious. Places like theatre and cinema auditoriums are designed to seat specific numbers of people. Most spaces, however, are not like this; they do not contain fixed numbers of seats. So, for such spaces some other way has to be found to determine how many people they might accommodate. The purpose is to discover the maximum number of people there might be in a space and who might, therefore, require to escape in the event of fire.

The usual practice is to apply what are variously termed occupancy or floor space factors. Different factors are applied to different kinds of activity, recognizing that some activities are inherently more crowded than others. Yet why the factor for a given activity in one country should differ from the factor for the same activity in another country is not so clear. The table that follows compares the factors (where they exist) for England and Wales on the one hand, and for Scotland on the other. In both cases, the actual number of people a space is considered to accommodate is found by dividing the floor area by the factor given.

Description/purpose of room/storey	Factors England and Wales	Scotland
Art galleries		4.6
Assembly halls (no fixed seats)		0.5
Bars, bar lounges, etc.	0.3	0.5
Bedrooms (ex. in houses, flats, etc.)		4.6
Billiard rooms, pool rooms, etc.		9.3
Bowling alleys		9.3
Cafes	1	1.1
Canteens, mess rooms	1	1.1
Clubs		0.5
Committee rooms	1	1.1
Common rooms	1	1.1
Concourses		0.7
Conference rooms	1	1.1
Crush halls		0.7
Dance halls		0.7
Dining rooms	1	1.1
Dormitories		4.6
Enquiry rooms		3.7
Factories (work spaces, stores)		4.6
Grandstands (no fixed seats)		0.5
Kitchens	7	9.3
Libraries	7	4.6
Lounges (hotel, etc.)	1	1.9
Museums		4.6
Offices (individual)	7	3.7
Offices (open plan)	5	5.1
Reading rooms	1	1.9
Restaurants	1	1.1

Shops (generally):		
basements	?	1.4
ground floors and above	2	1.9
Shops (expensive or bulky goods)	7	7.0
Shops providing services only	2	1.9
Staff rooms	1	0.5
Storage accommodation	30	27.9
Studios (radio, t.v., film, sound)		1.4
Terraces (stadia)		0.5

It will be appreciated that spaces with larger factors are considered to hold fewer people.

Where a space might combine two or more roles, the more (or most) onerous applicable factor (i.e. the smallest) is used.

Number of escape routes

It has already been observed that in certain places or circumstances building codes may permit just one escape route, and that while this may be very convenient for the architect or designer, it is less than reassuring for the users of the building. It was suggested that it would be better to adopt the principle that no matter where people might be in a building there should always be at least two possible escape routes available. In the U.K., however, regulations do sometimes permit a single escape route, a distinction being made between situations where there is (a) only one escape route absolutely and (b) where an initial single escape route later diverges to give more than one. For the

record, here is a list of those circumstances where, under current legislation, one escape route only (i.e. no choice of route at any point) may be permitted in England and Wales, and in Scotland.

England and Wales

Residential buildings A single escape route may be permitted in houses with top-most floor levels less than 7.5m above ground level, providing no bedroom is an 'inner room' (i.e. one reached only via another 'access' room) and that, in the case of houses with top-most floor levels between 4.5m and 7.5m above ground level, stairs are protected throughout.

Note: Basement bedrooms always require an alternative escape route.

Office buildings Single escape routes may be permissible in offices that are either compartmentalized or built in an 'open storey' configuration, providing travel distances do not exceed 18m or, where applicable, maximum direct distances do not exceed 12m.

Shops A single escape route may be permissible in a shop, providing it is not of the vertical open space type (i.e. different levels giving directly onto an open central well or similar configuration) and providing also that the maximum travel distance does not exceed 18m or, where applicable, the maximum direct distance does not exceed 12m.

Scotland

One escape route may be permitted where, in the following kinds of building only (classified by occupancy according to Scottish practice), the occupant capacity of a room or storey is sixty or less:

A2 (a) Individual single-level flats where access to all rooms is from the flat's own entrance hall; generally one escape (i.e. via the flat's front door) except where higher than 11m or 4 storeys (whichever is less) above ground level and where the travel distance to the front door exceeds 7.5m from any bedroom door or 15m from any other point.

(b) Individual single-level flats where not all rooms open directly on to the flat's own entrance hall. Here, only such rooms that do open directly on to the private entrance hall are permitted a single escape route, via the front door; this is also the case for entire single person flats situated not higher than either 11m or 4 storeys above ground level.

(c) An individual flat where all rooms are on the floor above its own main entrance and where all the rooms (except the kitchen, which is specifically prohibited from doing this) are entered from the flat's own entrance hall. There is generally one escape only, via the flat's front door providing that: the rooms are no higher than 11m or four storeys (whichever is less) above ground level and the maximum distance to be covered to the head of the stair does not exceed 15m from any point within the flat; or that the distance from any bedroom door to the head of the stairs does not exceed 7.5m and there are no built-in cupboards in the private entrance hall.

(d) An individual flat where all rooms are on the floor below its own main entrance and where all the rooms (except the kitchen, which is specifically prohibited from doing this) are entered from the flat's own entrance hall. There is generally one escape route, via the flat's front door providing that: the rooms are no higher than 11m or four storeys (whichever is less) above ground level the foot of the stair is enclosed to afford half an hour's fire protection, with a self-closing door doing likewise; the distance from any bedroom door to the fire-resistant stair enclosure does not exceed 7.5m; and there are no built-in cupboards in the upper level of the private entrance hall.

Note: In flats where the conditions do not exist which would allow a single escape route, additional escape routes are generally only required from bedrooms.

(e) In maisonettes where the height of any floor does not exceed 11m or four storeys (whichever is less) and where the distance to be covered from any point within the maisonette to the entrance door does not exceed 15m. A provision is generally made for one escape route, providing also that (i) internal staircases are enclosed to provide one half hour's fire protection (with self-closing doors likewise) and that (ii) certain other requirements in respect of travel distance and construction (according to the plan of the maisonette) are met.

(f) In houses of not more than three storeys above ground level, one escape route only is permitted providing the internal staircase is enclosed to give one half hour's fire protection in all its parts and, so, shall be separated from all rooms and levels (including any basement) to which it gives access by means of doors which for the most part are self-closing and which also afford half an hour's fire protection.

(g) In houses of more than three storeys above ground level, providing all bedrooms are at ground level.

Note: Houses of three or more storeys above ground level that do not meet the criteria for a single escape route as outlined above require additional escape routes from bedrooms above ground level only.

A3 (except in school boarding houses and in homes for more than ten handicapped people) where the floor height is not more than 11m above ground level and the occupant capacity is less than 26.

B1 Floors no higher than 11m above ground level.

B2 ⎫
C2 ⎬ Floors no higher than 4.5m above ground
D ⎭ level.

Basements used solely for storage and/or plant not more than 3m below ground level.
Roof level rooms for plant or water storage only.
Ground floor rooms generally with an occupant capacity of less than 61, that have direct access to an escape route leading to a protected doorway which discharges directly into a place of safety; and where the overall travel distance from any point within the room does not exceed 15m (18m in office, industrial and storage premises).
Within stairway enclosures Ticket, inquiry, reception desks, and the like; washrooms, and the like.

Protected lobbies

A protected lobby acts as an extra protective buffer between a protected zone and that part of the building the zone serves; or between a lift and a protected zone. It is a distinct and quite separate area, although technically part of the overall protected zone. Access to the lobby is always by way of fire-resistant self-closing doors, no matter which way one is going: either from the protected zone or from that part of the building served by it. Such walls or screens as may be required to surround the doors must also be fire-resistant. The specified minimum period of fire resistance is never less than half an hour and could be as much as four depending upon circumstances.

Protected lobbies are always required in certain situations, for example in many buildings having only a single escape stair. Elsewhere, their use can lead to a reduction in the total width of escape routes needed (see below). Normally, when calculating the required sum of all escape routes one or another of them is disregarded, to acknowledge the possibility of fire preventing access to it. Where all escape routes are guarded by protected lobbies, however, this is not thought to be necessary and all are taken into account. The result is fewer or narrower escape routes.

Are all escape routes the same width?

If a room or storey has more than one escape route, there is no actual need for them all to be the same width. None shall be less than a certain width, though, and when taken together their combined widths must not be less than is required to permit the safe evacuation of all those using the room or storey that the routes serve. (See below for further information on this.) It will be found generally more convenient, however, if they are all the same.

Calculation of the overall width of escape routes required from a room or storey can be gauged by following the steps shown below. These are based on the requirements of the Scottish Building Standards. They give accurate results for that country and are also a fairly good guide to what is acceptable in other countries where requirements are expressed in a somewhat more complex or diffuse fashion. They can be used for buildings of all types. In England and Wales, however, it is necessary to refer, inter alia, to various British Standards in order to find the necessary information which is given in tabular form according to the building type to which it refers. Two examples are given later.

To determine the width of an escape route proceed as follows:

1 Determine the number of people the area is to hold = P;
2 Determine the number of escape routes = R;
3 Determine whether or not there are to be protected lobbies:

 if the answer is 'yes' go to step 4, below

 if the answer is 'no' go to step 5 *et seq.*, below;

4a If $P < 101$, the minimum width of any escape route serving the area has to be whichever is greater, 800mm or $5.3P/R$.

4b If $P > 100$, the minimum width of any escape route serving the area has to be whichever is greater, 1100mm or $5.3P/R$.

Example 1: A conference room has a seating capacity of 100 and there are to be two escape routes via protected lobbies and protected zones. What should be the minimum width of either escape route?

$5.3P/R = (5.3 \times 100)/2 = 265$mm

$265 < 800$

Answer: 800mm

Example 2: A dining hall has a seating capacity of 880 and there are to be four escape routes, via protected lobbies and protected zones. What should be the minimum width of any escape route?

$5.3P/R = (5.3 \times 880)/4 = 1166$mm

$1166 > 1100$

Answer: 1166mm

5 Where there are to be no protected lobbies, the total width of available escape routes should meet the minimum requirement even when one (if they are all the same width) or the widest one is not taken into account. (Clearly, if there is only a single escape route anyway, it cannot be discounted.)

The procedure is:

6 Calculate $5.3P = W^1$ (as above);

7 Calculate (a) $800R = W^2$, if $P < 101$, or

(b) $1100R = W^2$, if $P > 100$;

8 Compare the two results obtained in steps 6 and 7 (above): call whichever is the larger W;

9 Calculate $W/(R - 1) = w^1$

w^1 = minimum width for any escape route from that area.

Example 3: Another dining hall with four escape routes also seats 880 ; however, in this case, there are no protected lobbies.

$5.3P = 5.3 \times 880 = 4664 = W^1$ [step 6]

$1100R = 1100 \times 4 = 4400 = W^2$ [step 7b]

$4664 > 4400$

$4664 = W$ [step 8]

$W/(R - 1) = 4664/(4 - 1) = 1555$ approx. $= w^1$
[step 9]

In this example, therefore, no escape route may be less than 1555mm wide. So, all four might be that width; or some might be more than that. The important thing, in this case, is that when you total the width of any three, the result should equal or exceed 4664mm.

It is obvious that where there are no protected lobbies, escape routes have to be wider than would otherwise be required. (Compare the examples of the two dining halls.)

10 An alternative way to discover the minimum width of any escape route from an area without protected lobbies is to apply the formula

$WR/(R^2 - R)$

Thus, in the case of the second dining hall:

$(4664 \times 4)/(4^2 - 4) = 18656/12 = 1555$mm approx.

Table of minimum escape route widths in shops as determined by the maximum number people intended to use them. (Derived from BS5588 (Part 2) 1985, and applicable in England and Wales.)

Max. no. people	Min. width of escape route (mm)
50	800
110	900
220	1100
240	1200
	but thereafter increasing uniformly at 5mm per person. Intermediate values may be interpolated

Table of minimum escape route widths in offices as determined by the maximum number of people intended to use them. (Derived from BS5588 (Part 3) 1983, and applicable in England and Wales.)

Max. no. people	Min. width of escape route (mm)
50	826
110	926
220	1100
240	1200
	but thereafter increasing uniformly at 5mm per person. Intermediate values may be interpolated

The width of escape stairs

The formulae and tables above refer to straightforward situations, that is, single rooms or single storeys. Where escape routes converge, it is usually just a matter of aggregating their widths to discover the width required for the new combined route. The overall width of an escape stair that serves more than one floor, therefore, is calculated according to the total number of people who would use it; not just those from one floor, but from all the floors it serves. In theory, it would be possible to increase the stair's width as it descends in response to the growing number of people it serves with each succeeding floor. (The assumption here, of course, is that escape stairs are escaping down, which is usually the case, though not always.) In practice, however, this can give rise to constructional and planning problems that outweigh such apparent logic.

Another underlying assumption is that all floors evacuate at the same time. In non-compartmentalized buildings of relatively few floors this is usually true. In very tall buildings it is not or, rather, it cannot be true. Escape stairs for very tall buildings that were capable of discharging the building's entire population simultaneously would have to be so wide that lower levels might consist of little else but staircases. Instead, it is generally supposed that tall buildings are evacuated in phases and, indeed, tall buildings have to be compartmentalized to make this permissible. Because the building is subdivided internally (horizontally, vertically or both) to inhibit the spread of fire, phased evacuation should be possible. This is normally done two floors at a time, starting with the floor where the fire is located and the floor immediately above it.

Thereafter, other adjacent pairs of floors are emptied as may be necessary. That is the theory. Its success, however, depends on there being:

1 early and faultless identification of the seat of the fire;
2 a system for alerting occupants in successive stages;
3 people who can control the evacuation effectively;
4 a well understood fire drill.

What it means for the building designer is that, as British law stands, escape stairs in compartmentalized buildings need only be wide enough to evacuate the two vertically adjacent floors that have the greatest combined occupancy. But where a building is not divided into compartments for the purpose of checking the spread of fire, any escape stair must be wide enough to serve all the levels it connects, not just the two most densely occupied. Consequently, an escape stair in a three-storey building could well be wider than one in a building of twenty-five storeys.

10

Planning Strategies

There is a certain fascination to be had from separating the planning from other aspects of designing. Whether it is a new building or an adaptation of an existing one, there can be a strong temptation to think about the planning first and allow other parts of the overall problem to follow. There may be occasions where, indeed, this is the only feasible approach: where it is immediately evident that unless a workable plan can be arrived at the whole project is in jeopardy. It might be suspected, for instance, that although a site appears big enough for the purpose of a proposed building, its proportion, shape or access might prevent a wholly practical plan. Similarly, an existing disused building might well be big enough for a projected new use but its configuration could dictate plans that would defeat it. In situations like these it is frequently necessary to concentrate on planning initially, possibly as part of an actual feasibility study, in order to determine whether or not there is any purpose in proceeding. It has to be said, if the building is not going to work, if it does not

allow the users to go about their business in a way that is not compromised by the building itself, then there is no point in building it.

Fortunately, the constraints exerted by most sites and existing buildings leave some room for manoeuvre. There is usually scope for the designer to approach the problem in a more generalized way; questions of planning can be subsumed within a general concept. It is possible to start with, or evolve, a broad idea about the building as a whole: an idea which is not wholly concerned with matters of planning. Instead, questions of aesthetics, context, structural forms, meaning and other kinds of cultural reference, as well as of planning, can play important roles even as a building or its interior is being conceived. Sometimes, all such considerations may have equal weight right from the start. At other times, their relative importance will vary even though considered together. Or else, just one or two can dominate initially, the influence of the others not being felt until later.

So, planning may be the very exercise which alone initiates a building design project. Or it may be one of a group of factors to be balanced, one way or another, either simultaneously or in sequence. It would be a mistake, therefore, to assign planning an absolutely fixed position in the general design schema. However, since a building's usability (that is the fundamental reason for building) depends largely on its plan, it makes sense to deal with the question much earlier rather than later.

At whichever point planning occurs the strategy is much the same. Whether it is to be the plan alone that determines all other aspects of the building, or whether the plan is one of a group of determinants, the strategy is remarkably similar. In the first case, you are using it to initiate the plan. In the second, it is being used to check a plan that may be already partly determined and then to evolve it further.

The broad strategy is this:

1 establish the brief and discover, particularly, the nature of all activities to be accommodated;
2 determine how, in practice, those activities will relate to each other;
3 assess the extent and, therefore, importance of such interrelationships;
4 establish requirements for spatial proximity;
5 work out the area required (square metres) for each activity and whether such space has to be exclusive, that is, dedicated to that activity alone;
6 construct proportional diagrams showing not only the areas needed but also exactly where they need to be relative to one another;

7 construct additional diagrams to show alternative overall configurations but which have the same internal connections.

Note: In all seven stages it is important to consider problems from the viewpoints of all users.

The results of the broad strategy outlined above can be used to generate a plan where it is the plan, ab initio, that is to determine the building as a whole. Alternatively, they can be used to check the efficacy of plans which have already been partly determined because of other factors (such as pre-existing building shells, access, etc.) and then to develop them further.

Each of the seven stages will now be looked at in greater detail.

Establish the brief and discover, particularly, the nature of all activities to be accommodated
Quite a lot has already been said in Chapter 2 about establishing a brief and this should be consulted. Remember that you are trying to answer three questions, the most fundamental of which is:
1 What does the client want to do inside the building: In other words, what activities is it intended to house?

Do not forget the other two which are:
2 What does the client hope to achieve, in addition to practicality, as a result of commissioning a new building or interior?
3 What do you, the designer, hope to achieve?

The answers to the first of these broad questions will have most bearing on the plan, but may well be modified by the other answers.

Determine how, in practice, those activities will relate to each other

To do this, you need to know something about the activities themselves. Indeed, you need to know everything about them that might affect questions of planning. It is wise not to assume too much in the way of prior knowledge. Even though an activity is one with which, ostensibly, you should be familiar, do not presume to know how your client wants it done. You must find this out. This, of course, is even more important in the case of activities you have not previously encountered. The client or the users (often both) have to be quizzed very closely about their methods. In order to do that effectively, you will need to have done some finding-out for yourself to be able to ask pertinent questions and, perhaps, to be able to suggest suitable alternatives. Unfortunately, it is very common for architects to provide areas for specific activities without having troubled to find out how, exactly, they are performed. This is particularly true where the client is not himself the direct user. In this situation, for any one of several reasons, there can be a huge gulf in communications between the designer and those for whom, ultimately, he is designing. A good designer, however, digs deep.

Activities do not exist per se. Activities are what people do. Therefore, it is important to ask who it is that performs, or is involved with, any particular activity. Rarely is it just one person. Without considering all the people involved in an activity, a very lop-sided view can result. It is all too easy to see shopping, for instance, from the standpoint of the shopper and to ignore that of the shop management, sales staff, back room staff, delivery drivers, and others involved.

In this way, the interrelationship of activities is not just a question of causality, of how one process is connected with and affected by another. It is also concerned with patterns of human movement, those both of the individual and of whole groups or networks of people. Who does what, how, when and with whom? Answer these questions and you are on your way to answering another one: where?

Assess the extent and, therefore, importance of such interrelationships

One of the main purposes of planning is to ensure that the facilities provided for any activity are to be found where both practicality and logic would dictate. The concern, therefore, is for proximity, making sure that the space for activity 'A' is adjacent to that for activity 'B' if there is a causal link between them, or else some kind of logical link that would affect the building's utility. To revert to an earlier example: in an art college it makes logical sense to put all the drawing studios together since it makes them easier to locate as a group and defines the activity of drawing more emphatically. It also makes practical sense to position the costume wardrobe, the properties store and the models' changing rooms and showers near to the studios.

Where there is a close practical connection between activities, such as the use of some common facility, it requires no great feat of percipience to know that they should be located to make this possible. The need for

interconnected facilities is less obvious, perhaps, where it depends on other factors, such as:

1 the frequency with which people must go from one set of facilities to another;

2 the numbers of people who must go from one place to another;

3 the relative lengths of time spent in one place or another by people who must move between them.

In other words, if individuals must go frequently from A to B; or if there is a pattern of large numbers of people going from A to B; or if someone's time is more or less equally divided between A and B; then there could be good reason to locate A and B close together, even though the activities in the two places are not themselves physically interdependent.

The underlying assumption is that to travel more than is absolutely necessary from one place to another is to waste both time and effort. (However, this is no reason why a building should not be a pleasant place in which to walk.)

It will be evident that in any building, unless intended for very limited purposes, there will be numerous activities all interconnected to a lesser or greater degree. How does one quantify this? How does one establish how great or small a degree of interconnection there should be between one pair of activities and another? Here is a possible, though limited, stratagem:

1 list all activities that occupy space;

2 combine all activities in a matrix (Matrix Type A), noting in a separate column the numbers of people involved in each activity;

3 use the upper half of the matrix to identify all pairs of activities that need to be physically interconnected to some degree or other and for any reason;

4 in the lower half of the matrix enter the total numbers of people involved in each interconnection previously identified (If you think that questions of status arise, then you can devise and incorporate a suitable weighting system, some individuals counting as 1, others as 2, 3 or 4, etc.);

5 enter these totals (5) in a table in descending order of magnitude.

Such a table acts as a crude index of the need for interconnection, measured in terms of the numbers of people needing to go from one facility to another. If you or your client subscribe to the view that travelling time is wasted time, then it could serve as a general guide to the relative distribution of those facilities: the higher a pair of facilities is in the table, as represented by a single number, the nearer together they should be. Note, though, that this is only a very general indicator and that in planning a building there are many other factors to be taken into account and to be weighed in the balance.

The stratagem just outlined can give a broad idea of the relative distribution of all activities within a building if the total time absorbed by all journeys made there (and hence their effective cost) is to be minimized. It gives a very general picture of where, in a building, things should be done, relative to each other although not to anything else. It does not, for instance, account for factors such as view, services or orientation. Nor does it tell you the precise relative locations. This is, however, possible using two other stratagems, at least for those pairs of activities needing direct mutual access.

The first of these next two stratagems is another matrix (Matrix Type B), more or less the same as the previous one. However, it is used as a device simply to identify those pairs of activities that do, indeed, require mutual direct access. As before, all those activities that require the provision of space are listed on the matrix twice, starting at the top left corner and in the same order, (a) down the left side and (b) across the top. A diagonal line is then drawn from top left to bottom right and the area either above or below it (it does not matter which) is disregarded. Each square on the grid represents the possible interconnection of two activities: that written at the head of the column and that at the end of the row which, together, define the square.

There is thus one square on the grid for every possible pair of activities and by working through it systematically you can ask the following key question of every possible pairing; 'Is it necessary to get directly from the facilities for A to the facilities for B?' where A and B are any pair of activities in the matrix. It does not matter why direct access is required – whether it is because of work patterns, machinery layouts, or whatever – but it is important to be very strict about the answers, which can only be 'yes' or 'no'. Unless you can answer with an unequivocal 'yes', then the answer is 'no'; there can be no 'maybe'. For every 'yes' a tick is placed in the appropriate box. All other boxes can be left blank.

The next stratagem follows on from the last and makes use of the information it was used to gather. It converts that information into a net, a diagram in which there is a separate circle for every activity and lines going

Matrix Type A

	RECEPTION [1]	+	+	+	+	+	+	+	−	−	+
1	TOILET [0]	−	−	+	+	+	+	+	+	+	
1	− CHANGING [0]	−	−	−	−	+	+	−	−		
1	− − WAITING [0]	+	−	−	+	+	−	+			
2	1 − 1 DISPENSING [1]	+	+	+	+	−	+				
2	1 − − 2 RECORDS [1]	+	+	+	+	+					
1	0 − 1 1 RECORDS ISSUE [0]	+	+	−	+						
3	2 2 2 3 3 2 CONSULTING [2]	+	−	+							
−	1 1 1 − 2 1 3 X-RAY [1]	+	+								
−	0 − − 1 − 1 PROCESSING [0]	+									
1	0 − 1 1 0 2 1 0 STAFF AREA [0]										
12	**6**	**4**	**5**	**11**	**13**	**6**	**22**	**11**	**2**	**6**	Totals

Key: + access required by staff
 − no access required by staff

Totals provide a crude measurement of the importance of accessibility to each facility, based on the numbers of staff involved, if known, the totals can be multiplied by the frequency with which staff go from one facility to another, for more usable results.

RECEPTION [0]	+	+	+	+	+	−	−	−	−		
11 TOILET [3]	+	+	+	−	−	+	+	−			
14 9 CHANGING [6]	+	+	−	−	+	+	−				
14 9 12 WAITING [6]	+	−	−	+	+	−					
15 10 13 13 DISPENSING [7]	−	−	−	−	−						
− − − − − RECORDS [0]	−	−	−	−							
RECORDS ISSUE [0]	−	−	−								
14 9 12 12 − − − CONSULTING [6]	+	−									
10 5 8 8 − − − 8 X-RAY [2]	−	−									
− − − − − − − − PROCESSING [0]	−										
− − − − − − − − − STAFF AREA [0]											
78	53	68	68	51	−	−	55	39	−	−	Totals

Key: + access required by patients
 − no access required by patients

Here patient numbers and frequency have been combined to give the factors for each facility. The resulting totals give a good indication of the relative need for accessibility.

Matrix Type A
ABOVE: *analysis of required accessibility within a small clinic as seen from the standpoint of the staff. Matrix shows activities required, with space and numbers of staff permanently employed in each.* BELOW: *analysis of required accessibility from the patients' standpoint. Matrix shows activities required, with space and numbers of patients an hour using each facility (i.e. numbers and frequency combined).*

*Matrix Type B
A simpler matrix
used to find
answers to the
question 'is it
absolutely
necessary to be
able to get directly
from the facilities
for activity x to
those for activity
y?' where x and y
are any pair of
activities. In this
example, the need
for direct access
between facilities
in a small clinic is
examined both
from the staff
standpoint and
from that of the
patient .*

Key: + direct access required between facilities
 - no direct access required between facilities

Matrix reveals the need for proximity as well as accessibility.

from one circle to another where a need for direct interconnection was identified in the matrix. Each line has to be straight, take the shortest route between the two circles it connects, not cross other circles and not cut across any other line. This can be quite easy to do where few direct interconnections are required, but in other cases the originally arbitrary arrangement of circles may have to be rearranged numerous times in order to fulfill all the conditions. Even then it may not prove possible. This means that it is not possible to achieve an optimum interrelation of activities on one level. In buildings of more than one floor this may not matter. Yet it will be necessary, then, to reinterpret the diagram as having three dimensions, superimposing some circles over others to achieve the required proximity. If, however, the building is single-storey, then it becomes necessary to reassess the matrix with a view to eliminating one or more of the desired interconnections. In other words, something has got to give. By contrast, it is sometimes found that there is more than one way in which a net can be laid out in order to achieve the same result.

It will be appreciated that a net is a significant step between a verbal description of proximity and an actual plan.

Assuming, then, that you can get a net that works, there is a further stratagem you can employ to get even closer to a plan. This involves drawing the successful net (or nets) again, but making the circles proportional in size to the space required by the activities they represent. Since nets and matrices tend to be used early in the design process, proportional nets cannot be all that precise but

they are still useful. Therefore, assuming you know how many people are involved in the given activities, and assuming you know or can find out how many square metres per capita should be allowed in each case, it is easy enough to revise a net, with large circles for those activities needing lots of space and proportionately smaller circles for activities with more modest requirements. Since this is likely to deform the original pattern of short straight lines, drawing the net yet again is likely to be necessary. Still, all the time you are getting closer to an optimum plan relationship, at least concerning the direct interconnection between certain facilities.

That is about as far as one should go with stratagems of this kind. The results should be paid due regard but not used slavishly. As has already been remarked, there are many other factors to be taken into account when devising a building's plan. The matrices and nets have simply been devices to clarify what is required, ideally, of the plan regarding the proximity of activities. What now has to happen is a balancing of that knowledge against all those other factors that have a bearing on where, in a building, things should be. It is here that the particular sensitivity which architects and interior designers ought to possess takes over from mere processes.

The results from a matrix can be printed out as a net. Here is an example of a net derived from the earlier example of a type R matrix. Each facility listed in the matrix is represented by a

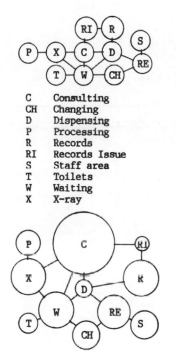

C	Consulting
CH	Changing
D	Dispensing
P	Processing
R	Records
RI	Records Issue
S	Staff area
T	Toilets
W	Waiting
X	X-ray

separate circle. Wherever the matrix reveals the need for direct access between two facilites, a straight line is drawn between the two corresponding circles. Ideally the line should be as short as possible and ought not to cross. Routes must be direct, and not circuitous. Reorganize until a good net is obtained. If crossed lines persist an arrangement on a single level without intervening circulation spaces is not possible. Alternatively, reorganize the matrix.

Appendix: Internal Planning Factors

This is a list of factors that can affect specifically the planning of buildings and, therefore, of their interiors. Many have already been touched upon in the main part of the book.

Specific schemes can be checked against the list line by line.

1 Activities to be accommodated
2 Numbers of people involved
3 Relevant details of occupants and users:
 a age
 b sex
 c health
 d mobility
 e special characteristics
4 Relationship of people concerned
 a social
 b work: management system and chain of command
5 How are activities to be performed?
6 Interrelationship or interdependence of activities
7 Operational or activity sequences
8 Circulation requirements
9 Security
10 Supervision
11 Privacy: absolute or relative
12 Cultural or social patterns or mores
13 Protection from
 a noise
 b heat
 c smells (external sources)
 d dust (internal sources)
 e physical danger
 f visual intrusion
14 Regulations, legislation: national and local
15 Minimum areas for specific purposes per se
16 Minimum areas per capita for particular purposes
17 Ideal room proportions for particular activities
18 Height requirements
19 Aspect

20 Relationship to site

21 Relationship with adjacent buildings or adjacent parts of the same building

22 Relationship to public areas outwith the site

23 Direction of approach for

 a regular occupants

 b visitors

 c deliveries

24 Means of approach for

 a regular occupants

 b visitors

 c deliveries

25 Means of access for

 a regular occupants

 b visitors

 c deliveries

26 Escape

27 Daylighting

28 Solar gain

29 Heat loss

30 Ventilation and fresh air

31 Draughts

32 Requirements for services

33 Heating system

34 Drainage system

35 Hot water system

36 Generation of noise, heat, smells or waste

37 Furniture: loose or fixed

38 Fittings and equipment

39 Layout of furniture and equipment

40 Storage

41 Structural requirements

42 Existing structure

43 Existing fenestration, openings, etc.

44 Existing services

45 Safety

46 Ambience

47 Existing architectural qualities or features

48 Budget

Index